PHOTOGRAPHING
CREATIVE
LANDSCAPES

Simple Tools for Artistic Images
and Enhanced Creativity

MICHAEL ORTON

AMHERST MEDIA, INC. ■ BUFFALO, NY

Dedication

To photographers everywhere, who wish to make the creative choice.

To Dan Dorotich, for inviting me to my first workshop experience, and forcing me to reach for the next "plateau."

To my wife Mary, and sons Jeremy and Ryan, for the unconditional support over these past years. This could not have happened without you.

Page 5—Passage from *Making Color Sing*, by Jeanne Dobie (Watson-Guptill Publications, New York, 1986) reprinted by permission from Watson-Guptill Publications.

Published by:
Amherst Media, Inc.
P.O. Box 586
Buffalo, N.Y. 14226
Fax: 716-874-4508
www.AmherstMedia.com

Publisher: Craig Alesse
Senior Editor/Production Manager: Michelle Perkins
Assistant Editor: Barbara A. Lynch-Johnt

ISBN: 1-58428-048-4
Library of Congress Card Catalog Number: 00 135907

Printed in Korea.
10 9 8 7 6 5 4 3 2 1

Table of Contents

Preface

Have you ever looked into a lake or pond or even a rain puddle and discovered with surprise that the reflection looks better than the actual scene? Something indefinable happens when the subject is transposed. It is not quite the same as the scene; it is an "image" of the scene. When we, as artists, view a landscape, our minds also act as mirrors, reflecting what we see much like the lake or pond. Therefore, to be creative, we should paint the reflection in the mind, and not the scene.
—From *Making Color Sing*, by Jeanne Dobie. Copyright © 1986 by Jeanne Dobie. Published by Watson-Guptill Publications, New York.

Photographing the "reflection in the mind" has been a fascination for me since I began to photograph. I hope that this book will help others enjoy this challenge in their own photography. The landscape is only the beginning as we adopt new ways of seeing, and bending the way that we respond in our search for the creative.
—Michael Orton

Introduction

ALLOW ME TO PAINT A PICTURE. You are a photographer, one who enjoys taking pictures with your camera. On a shelf in the closet are all of the instruments of photography—cameras, lenses, some filters, and a tripod. Perhaps you are a member of a club, have a friend with the same interest, or are content to explore for images on your own. You are fairly familiar with the equipment you use, and have, over the years, spent considerable time, usually in spurts, hunting for pictures. It doesn't always feel easy or satisfying, and the moments of elation sometimes seem few and far between. More time is spent admiring other photographers' images in books and magazines, and occasionally your cameras gather dust and the film expires. Your interest wanes and wanders, but is sometimes tweaked to life—usually when the monthly photo magazine arrives in the mail. But then, realizing you can't go to Africa or Patagonia that week, the enthusiasm fades once again. You are not alone. You are with the vast majority of photographers, myself, at one time, included. But take heart! The images you so long to create are closer than you might imagine.

The images you so long to create are closer than you might imagine.

The book you now hold is not a how-to book in the traditional sense. There are already many of these on bookshelves—volumes dedicated to the calculable, mathematical, chemical, and mechanical considerations of photography. You have probably passed the point of needing lessons on film, lenses, ISO ratings, and learning to override the auto modes on your camera. What you really crave is enthusiasm, excitement, and discovery, culminating with the big C—creativity. I have been through this cycle myself, and eventually found the path that allowed me to create images that had once seemed beyond my grasp and imag-

ination. Now, instead of wandering and hoping, I am empowered. I have taken control of my photographic destiny. I feel the overwhelming satisfaction of using the simplest tools to create wonderfully artistic images, practically at will!

Why this book? Because it is now your turn. This book will help you place your own stepping stones; it will help you build your own creative pathway. It is a starting point, a point of departure. It is about finding the inspiration to explore not only the world around you, but just as importantly, within you. You will gain a new sense of confidence by having the vision and decision to lead you in new directions. You will begin to see objects you have already explored in wonderfully different ways, and, in doing so, uncover others you would have passed by. Your camera can move from its documenting role to become an instrument of creation, and from your mind, eyes, and hands will flow images that are not only unique, but also uniquely you! There is no feeling in the world of photography quite like it. That is what this book is about.

This book will help you place your own stepping stones...

USING THE IMAGE GALLERIES
The images in Gallery One are presented without accompanying technical information. A primary intent of this book is to introduce an open approach to the creation of imagery, not to merely dwell on the mechanics. Shutter speeds, F-stops and lenses are important but, to become more creative, we need to think beyond them.

In the captions that follow these images, I have related my rationale in making the decisions that I did with the images in gallery one. This is done to provide a basis for comparison that you can use as a springboard for your ideas in similar photographic situations.

My hope is that you will do the same thing with the other galleries in this book, as well. It can be very satisfying to recognize the options and respond—developing your own creative processes, rather than simply following, duplicating, and repeating standard instructions.

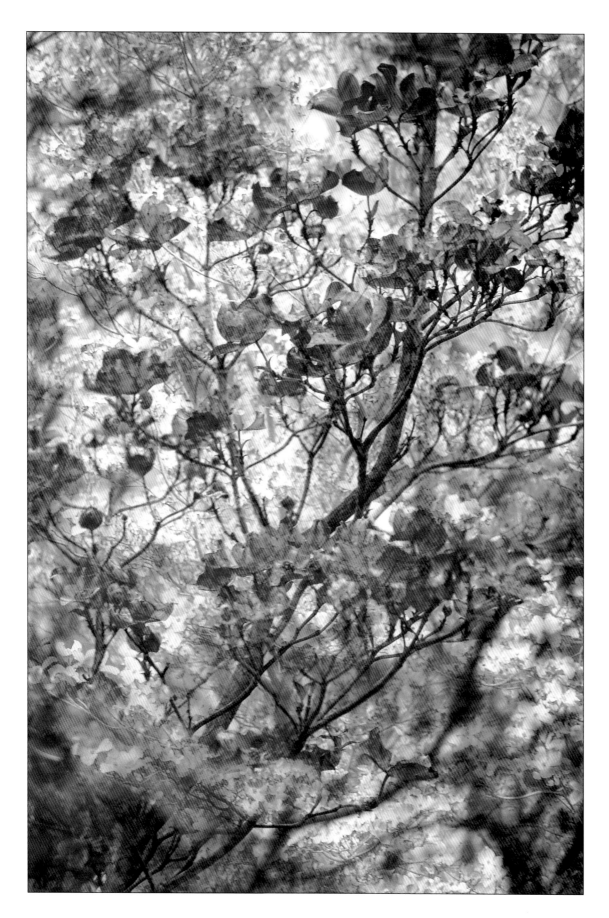

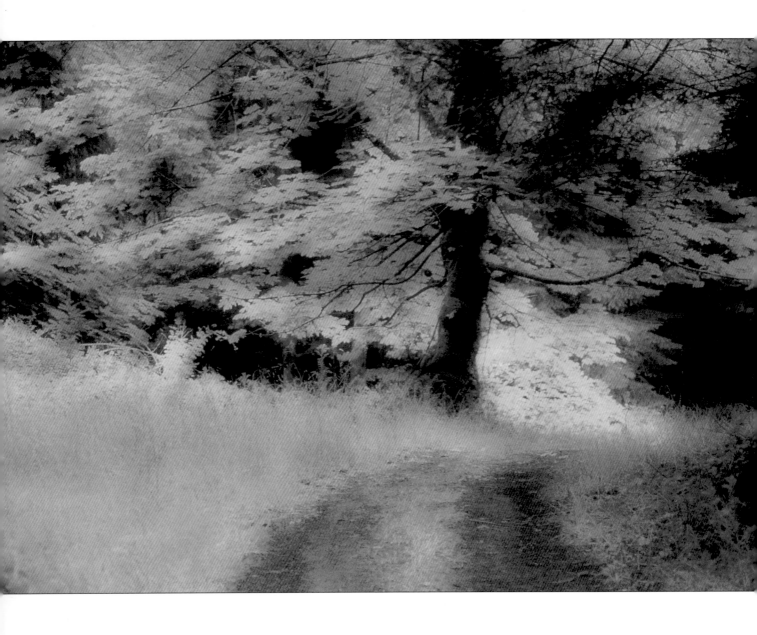

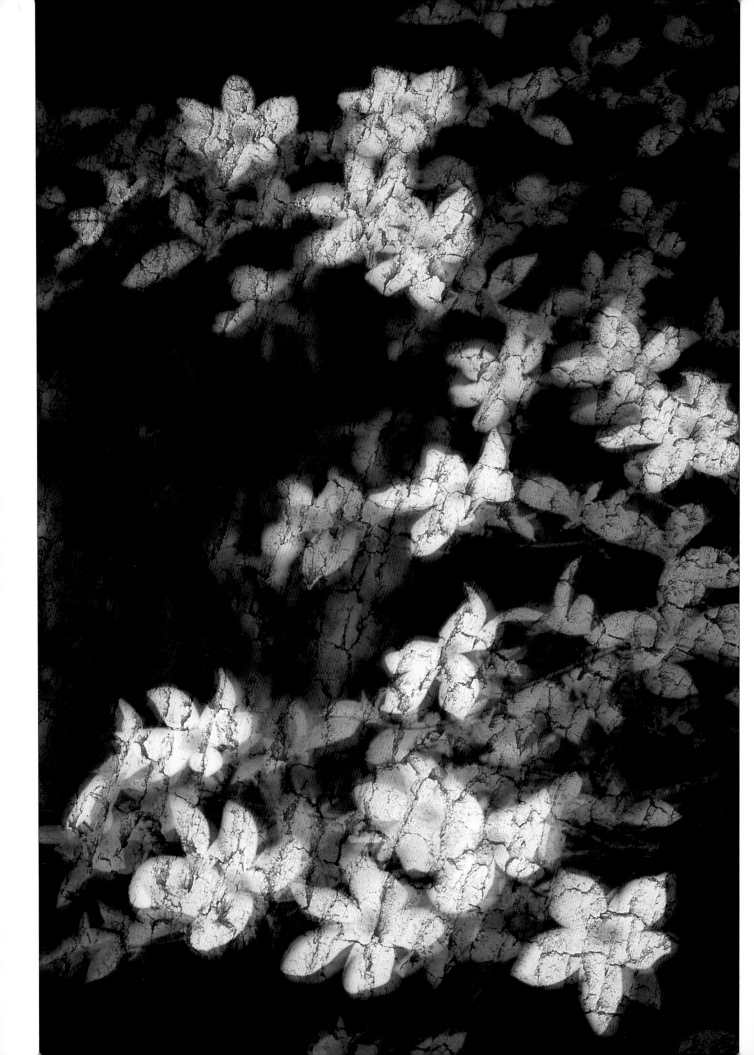

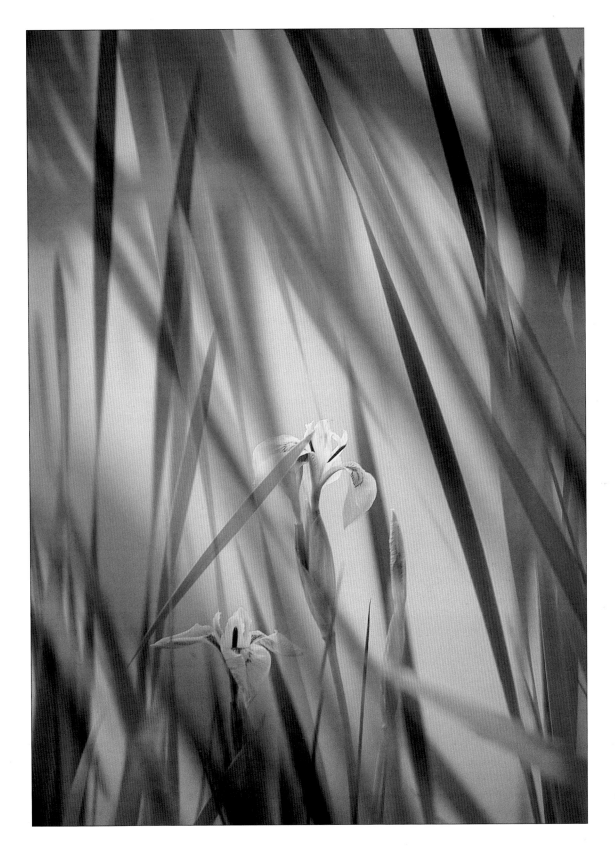

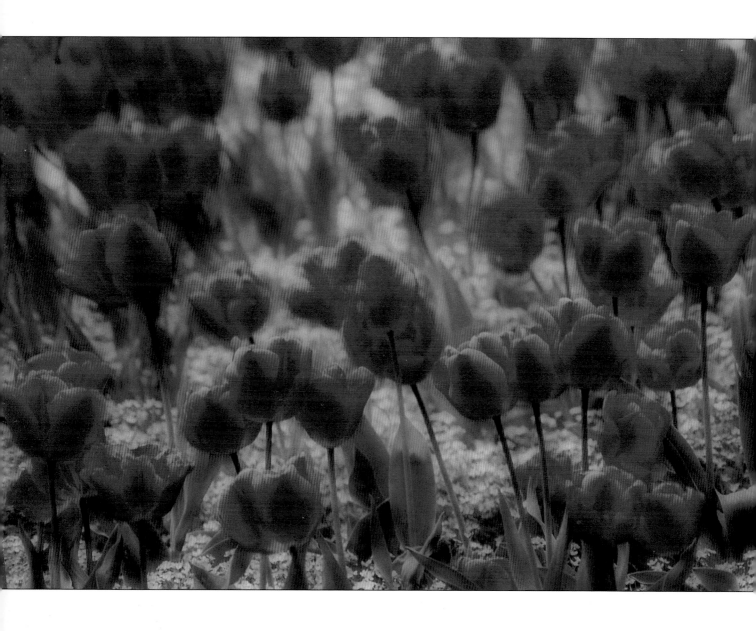

Pink Dogwood. The feel of this spring-time profusion of flowers and stems against an overcast sky reminded me of a Japanese-style painting with a lot of negative white space. With this in mind I realized that the light, overcast sky could be rendered near-white (with the appropriate overexposure of two to three stops). I selected compositions with the main stems placed obliquely, and noted as I did this the random pattern of the flowers when viewed from a distance. I complemented the original compositions with several of the random patterns, creating multiple options when later viewed on my light table. Initially drawn to the pattern of the soft spring pinks in the overcast light, I chose to overexpose, use several different angles of view, and to sandwich together an image of a branch of flowers with an image of a patterned mass of flowers.

...the grasses and leaves had not yet lost their fresh light green hues.

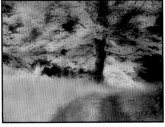

Maple Tree and Path. I came upon this scene on a late spring day when the grasses and leaves had not yet lost their fresh light green hues. I was limited as to the amount of tree that I could include in the image because of the distracting bright areas above. Bright overcast light created a wonderful translucence in the leaves and grasses, emphasizing the rejuvenation and new growth of spring. The placement of the path invites the viewer to walk into the image. The softness and the saturated color were created by sandwiching two slides, one containing the color component, and one with the detail. This technique is further explained in chapter 3.

Looking Down on Buttle Lake. There were many and varied reflections on the lake combining the sky, clouds, and surrounding hills. The water's surface had a regular pattern of ripples moving slowly across it.

Although they were interesting on their own when exposed "correctly," I began to gather overexposed images to be used with other components in slide sandwiches. An oblique orientation of the lines felt less regimented or restrictive than a horizontal or vertical one. This image is composed of two similar reflections sandwiched together, with one image reversed to provide even color and a more complex pattern.

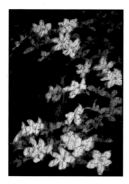

Dogwood Flowers. One would think that my primary attraction to this situation was the flowers. Actually, the stark contrast or tonal difference between the flowers and the darkened tree trunk behind them caught my attention. To emphasize this tonal difference even further, I made a slide sandwich of two exposures of the scene, and then sandwiched a third slide of oak tree bark, overexposed three stops, giving a painterly effect to the lighter areas.

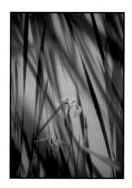

Irises. Skirting the shore of a pond edged with yellow irises, I created many compositions of the flowers with the supportive lines of the stems rising upward from them. With overexposure, the still, light gray water could be rendered near-white, but in my mind, there was a lack of complexity or mystery. I began thinking in terms of components, and concentrated on groupings of overexposed leaves and stems to be used as sandwich slides. This is one, reversed upside down, with a portrait of two irises.

Tulips. The intense color in this garden almost shouts for the attention of the photographic eye. The subtle greens of the foliage and the blues of the for-get-me-nots provide a dramatic backdrop to the vivid crimson. The light from an overcast sky created a translucence—a near glowing color—in the tulip petals, which I emphasized with a slide sandwich composed of two slides.

The intense color in this garden almost shouts for the attention of the photographic eye.

Creativity

WHERE DOES CREATIVITY COME FROM? What is it? Why do some people have it? Why don't I? These are all perfectly normal and expected questions that we ask ourselves in search of the seemingly intangible. There has long been a misconception that creativity could not be taught, that it was something inherited. The conclusion was that if you were not spontaneously producing "creative" work, you just weren't creative, and there was no point in trying. Truthfully, although there are some individuals who are able to rise to higher levels than others, creative potential exists in everyone, and the height a person's creativity soars to is determined largely by desire, dedication and persistence. Creativity does not just happen, we make it happen.

Where does creativity come from? What is it?

I would like to introduce you to a friend whom I consider truly creative. She is an artist, and merely being in the room and talking with her leaves me with an almost indefinable sense of inspiration. In the few years I have been privileged to have her acquaintance, she has focused, refocused, explored and communicated her talents in a way that has drawn a growing circle of admirers. If she were to present a showing of her work from the past fifteen years to those who do not know her, her work would be seen as the achievements of a dozen different individuals, each with unique artistic insights and responses. Doris embodies the word creativity. She shuns the easy road of creating an identity, refusing to generate work in a style that meets consumers' "decorator" needs (and continuing to fill that need ad infinitum). To Doris, there is always something greater to explore and uncover, no matter what the subject or medium; to Doris, boundaries are goals. She creates what she feels and viewers feel what she creates. Doris is

able to touch others' emotions because she is in touch with her own. Thank you, Doris.

Creativity...its definition will be a little different for each of us, but be aware that it is ongoing—it is the search, the trip, and not the destination. Creative photography is the freedom to explore, uninhibited, the multitude of relationships between the camera, lens, film, light, subjects, and ourselves. It involves abandoning some of our preconceptions and going beyond the assumed boundaries of a photograph.

You may feel that creativity is "over there" somewhere, and is out of your reach. Remember, a house is constructed one brick at a time, a melody one note at a time, a book one word at a time. Begin to think of creativity as a ladder, and move one rung at a time. It is likely that anyone reading this book has already taken a few steps on this ladder. This is not an ordinary ladder, for as we ascend, and our grasp on creativity becomes more tangible, the ladder's end disappears into the distance! Do not despair, this is good! I call this the creative climb effect. The more we explore, and experiment, and experience, the more creative inspiration we gather. With this, we are compelled to explore further, to experiment, and to experience more and more steps. The lower rungs begin to pass by rather quickly once your climb begins, and it doesn't hurt to look back (or down) and acknowledge this. Realize that your imagery has changed, and will continue to evolve, and that you are completely open to this. Creativity for photographers is the recognition and realization of our own curiosity!

Begin to think of creativity as a ladder, move one rung at a time.

This book is about creativity and the sources that inspire it. Not having a more familiar example, I will start with some of my own personal experiences, so bear with me. My first camera, a 35mm SLR, was a 37th birthday gift and came with only a small booklet of instructions. I was intimidated and tentative, but curious enough to load it with film and see what would happen. How could this inanimate object see so well? There were all kinds of things in those pictures that I didn't put there. This was frustrating! I examined stones, bugs, sticks, weeds, and puddles, and was far too overwhelmed to consider the larger landscape. This

was object-oriented imagery at its worst. I continued for some months until another gift appeared, a book by Canada's foremost creative photographer, Freeman Patterson. The images were stunning! Never had the saying "a picture is worth a thousand words" meant more. I poured repeatedly over them, attempting to unlock the secrets to how such visual perfection had occurred, or, more correctly, been created. From somewhere a distant voice whispered to me, "This is it!" I wanted so badly to make images like those in front of me. The decision was made. And sure, most of my initial images were bad, but it was a start! Unknowingly, I was on the ladder.

I wanted so badly to make images like those in front of me.

If there was a photo club in town, I was unaware of it, or too intimidated to show my face, but for some unexplained reason (could photography be art?) I attended the meetings and shows of the local art community. They talked about the world they saw in terms of tones, hues, edges, negative space, shadow, power, subtlety, saturation, pastels, motion, strokes, etchings and washes. All of these techniques were unfamiliar to me, but I listened and watched, intent on working in the same fashion with photography. Why not? This learning became a key to my creativity for the years ahead, and the cornerstone of the mode of thought I now employ. While in this stage of absorbing the world in new ways, and with my camera in hand, I hungrily devoured all available photographic images and other two-dimensional art. Inspired by this new insight into an artist's perceptions, I made a decision.

THE CREATIVE CHOICE

Creativity is possibly the word photographers use the most, and yet, one they act upon reluctantly and tentatively at best. We are great "tech-tip grabbers" and gadget collectors, trying to emulate the pro sponsors and promoters of our next must-have consumer revelation. The creative vision we occasionally conjure is too often mired in rules and guidelines enforced and propagated by other photographers and "formula" editors.

Let's be honest—as creative visionary artists, we photographers are too often the anchor, and not the ship of discovery we think we are (or would like to be). Where does this

leave us? What are our options? Well, you have picked up this book, and, in doing so, have expressed curiosity, interest and perhaps even desire. You may have begun to sense that there is a different way to go about photography, freedoms you yearn to experience, some boundaries that need knocking over, and you would be right. Our lives are full of choices; we make them constantly. Now is your opportunity to make one that will change the way you see the world. Do you wish to be creative? Please, say yes!

THE COMMITMENT

If your answer was yes, congratulations! You have made a decision that could ultimately propel your vision and imagery to destinations yet unseen. Was the yes simply out of passing curiosity to see what might happen with a little involvement? Or, could you repeat with conviction "From this day forth I will be as creative as I possibly can with my vision (how I perceive), and imagination (how I respond)." You may need to remind yourself of this decision from time to time.

If you take this dedication of purpose lightly and remember to use it only occasionally, then its effect on your creativity will be proportionate. Consider this if it helps. You don't have to erase the photographic knowledge and background you may have at this point, but instead, think in terms of supplementing and expanding upon the way you currently see and respond. This is the first step toward creativity, but also the most difficult. Falling back on the safe and established methods can happen all too easily, and in fact, often will. Over the years, I have regularly had to stop and redirect my thoughts if I wanted to experience the challenge of new discoveries.

Your creative effort may be misunderstood, even unappreciated by some whose only measurement for successful photographic images is that they be sharp, unmanipulated reflections of what is called the real world. This view has some merit, depending on the intended use of the image, but by the mere use of our cameras, we have already affected the viewers' response to the subject. Choice of film, lens, shutter speed, and aperture, selection and abstraction from the whole scene, and use of specific angle and quali-

Falling back on the safe and established methods can happen all too easily.

ties of light are, in fact, the photographers' desired interpretations. Without intending to create or to manipulate, the photographer who adheres to the strictest criteria has done exactly that. Professionals, photographers who have chosen to seek remuneration for their work, have set themselves on a sort of tightrope, attempting to satisfy editors, make sales, and achieve some kind of inner satisfaction. Can creativity exist in such conditions?

Contrary to what one might expect, my own experience in the world of stock photography tells me that it can. As a matter of fact, creativity is a necessity of survival. One must evolve or perish! When I find myself tightening up under the stress of travel and expectations of images not yet found, I recognize that it is time to take a step back, to remove the notion of price tags and clients' needs from my mind. It is time to reexamine where I came from and why, and once again, to exercise creativity for the pure joy and exhilaration of it! Ultimately, we are creative for ourselves. If this is not the case, creativity will suffer like a garden without water. It will wither away.

Creativity is a necessity of survival. One must evolve or perish!

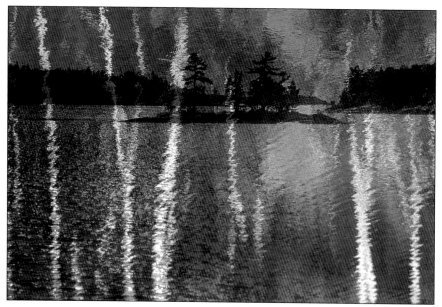

By considering the visual qualities of the land-scapes we observe, we begin seeing them as an artist's raw material, as a starting point rather than the conclusion of our expressions. This image illustrates how two components of the surrounding landscape can unite to convey a deeper impression of the whole. The offshore island was rendered as a black and white etching due to the extremely bright backlit reflection, and was overexposed to retain that brightness. The color wash is a reflection from a lake's surface only miles away, also slightly overexposed. The marriage of water, islands, and autumn color, combine to create an impression of Ontario's lake lands.

An "impressionist" working with photographic tools doesn't always get to see the final results of his or her responses while creating. We must visualize while rehearsing the strokes we've chosen to move our cameras with, at the same time, deciding on composition, depth of field, and exposure concerns. To create this image of birch tree trunks in a swamp of red willow brush, I chose an elongated oval camera motion that retained and emphasized the white trunks, yet softened the brush to a muted wash. My ini-

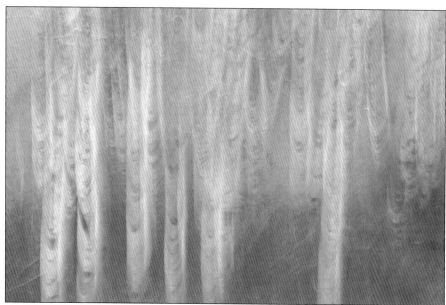

tial attraction was to the pattern of white columns, and sur-rounding restrained colors, due to the indi-rect soft light. I chose to overexpose slightly to retain this quality.

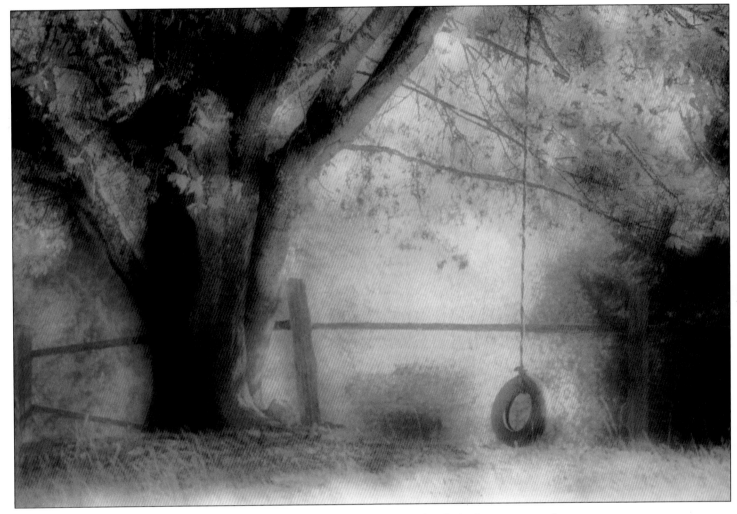

Returning to the site of a favorite landscape many times has taught me two things: one, it will never be the same again, and two, be prepared to accept its new form and respond to it. The above image was given a softened, nostalgic feel by sandwiching two transparencies. In the first image, the color component, I set the aperture to F4, creating a slightly out-of-focus image, which I overexposed one stop; in the other image, the detail component, I focused on the tree, set the aperture to F4—creating an out-of-focus background—and overexposed two stops. My initial attraction was to the restrained color and translucent qualities of the leaves that the misty, soft autumn light created.

My initial attraction was to the restrained color...

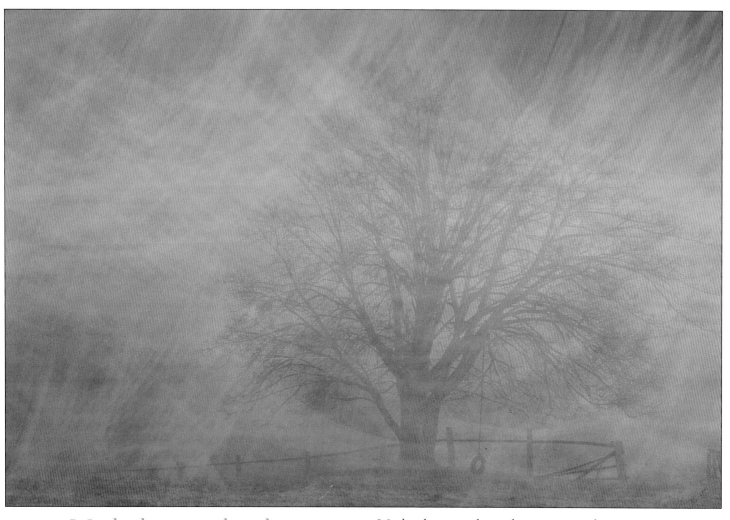

Weeks later, only a bare tree and swing remained against a gray sky.

Weeks later, only a bare tree and swing remained against a gray sky. I made overexposed images in which the expanse of the winter sky was dominant. This near-monochromatic silhouette was then given life on the light table when combined with an image of a field of flowers I created with a sweeping arc motion of the camera and put on reserve in my file of color washes. The attraction to the tree component was due to the graphic, tonal difference it presented against the sky's essentially negative space. The flower field, on the other hand, created a tapestry of color, a pattern that I chose to abstract from.

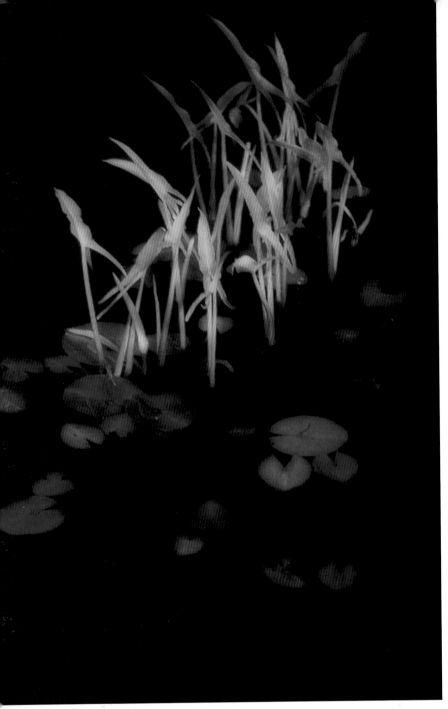

Slogging through black swamp ooze may seem an unlikely way to discover nature's mysteries.

In these images (left and opposite), water once again works its wonders in the landscape. Here, it is as mystical black, negative space. The dying light of day is moments from vanishing in the lily pad image (above). With a 70–210mm zoom on a tripod, I first removed all reflection from the water with a polarizer. This created a marked tonal difference between the plants and the water, which I then emphasized further in a slide sandwich. Since most of the image is near-black, the first slide, very slightly out of focus at F4, was exposed as "correct" with the camera's meter. The second image was in focus at F8, and was overexposed one stop. The resultant sandwich darkened the water even more, and held "correct" exposure for the lily pads. My initial attraction to this image was due to the tonal differences created by the extreme sidelight.

Slogging through black swamp ooze may seem an unlikely way to discover nature's mysteries, except in the case of skunk cabbages (opposite). Rubber boots and a polarizer were key to extracting this image. Careful composition was essential to obtaining this image; partial polarization left a hint of reflection against the dark water. For me, these were simple choices. The most attractive elements in this image were the vivid colors, stark contrast (tonal difference), and soft light.

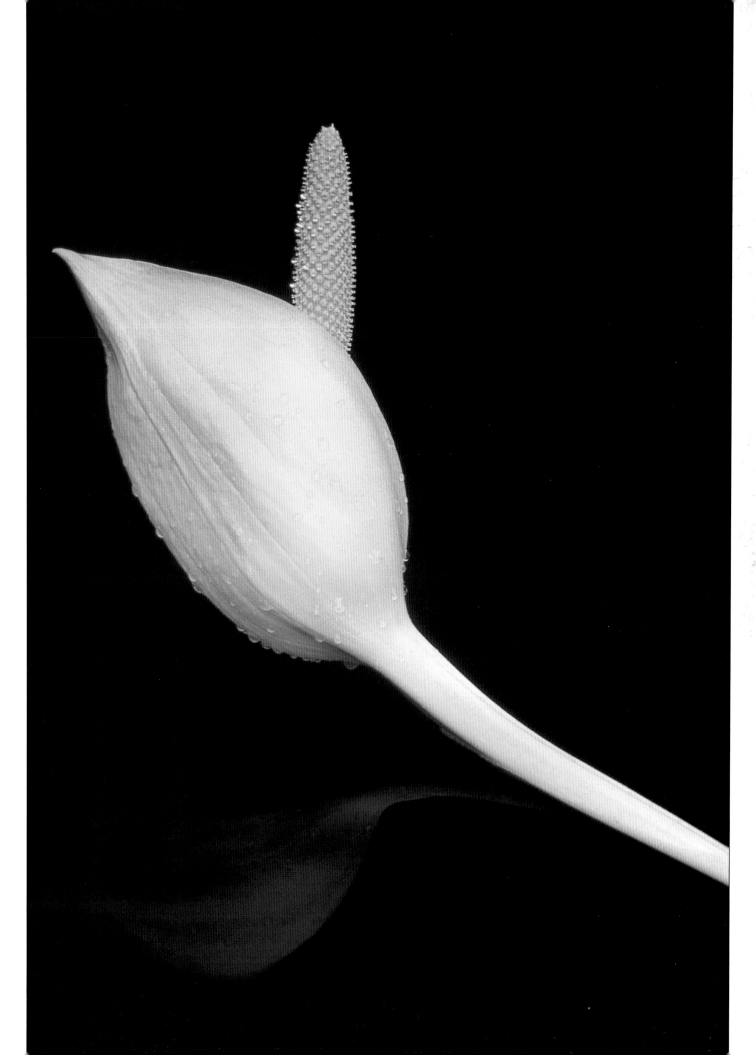

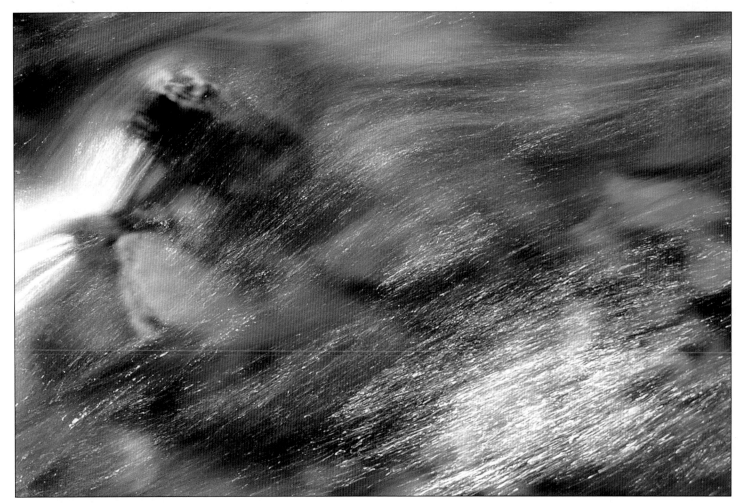

This image is quite unique in the way that the two elements were combined.

Combining elements of the landscape first involves the discovery of all of the available components. In the image above, the colored stones beneath the rushing water were not visible until the twist of a polarizing filter uncovered them. The visual raw materials that combined to make this image included color, bright overcast light, reflection, motion, and transparency.

The image on the opposite page is quite unique in the way that the two elements were combined. The first image, a windswept pine on a textured rocky outcrop in the angled evening light, is sandwiched with a close-up of the detailed pattern on the rocks. Total observation and absorption of the landscape will present wonderful opportunities more often than we realize.

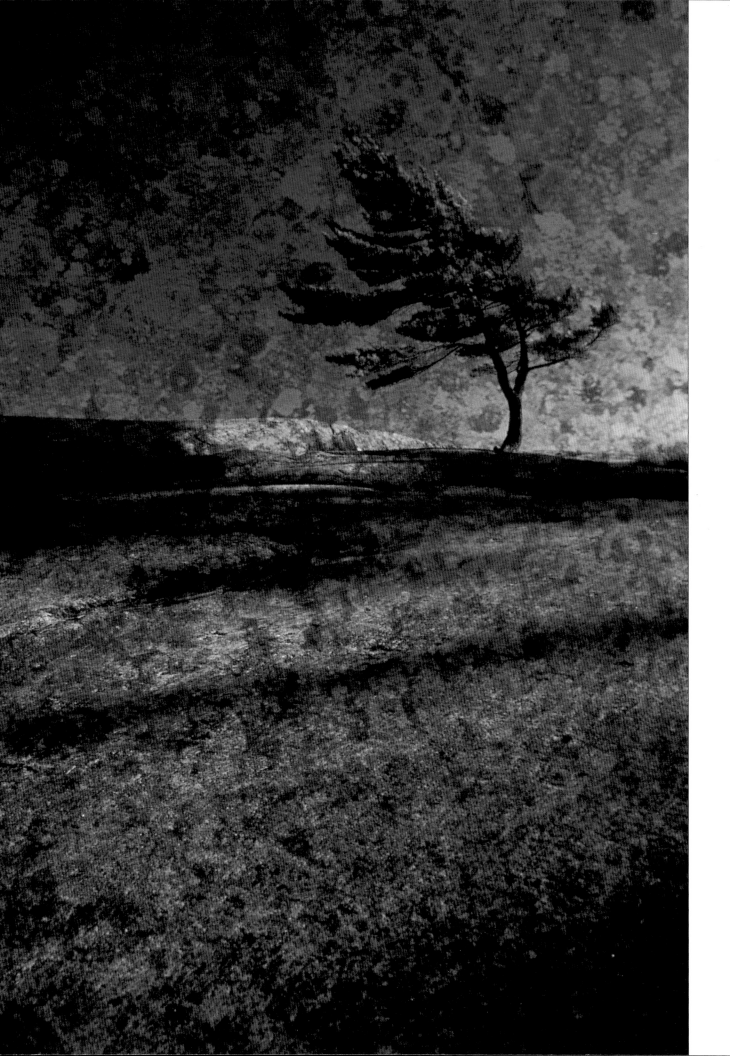

Painted
washes
of color
could yield
dramatic
imagery.

Flash, though not one of the choices landscape photographers commonly use, does have many creative applications. A careful consideration of the landscape you visit will help you realize situations in which painted washes of color could yield dramatic imagery in the darkness of night. Remember that lighter-toned surfaces will be more efficient reflectors when bouncing a flash. The bristlecone pine on the opposite page was a light-toned beige/gray. Against the night (with the assistance of my wife, Mary), I painted numerous combinations of complimentary color flashes from various directions.

The caverns above were a somewhat different situation because of the ambient illumination. We sought combinations where we could augment the existing light with various color flashes, while still retaining the eerie feel of this place. This necessitated covering the camera lens between flashes, a technique I used in creating the bristlecone pine image, as well.

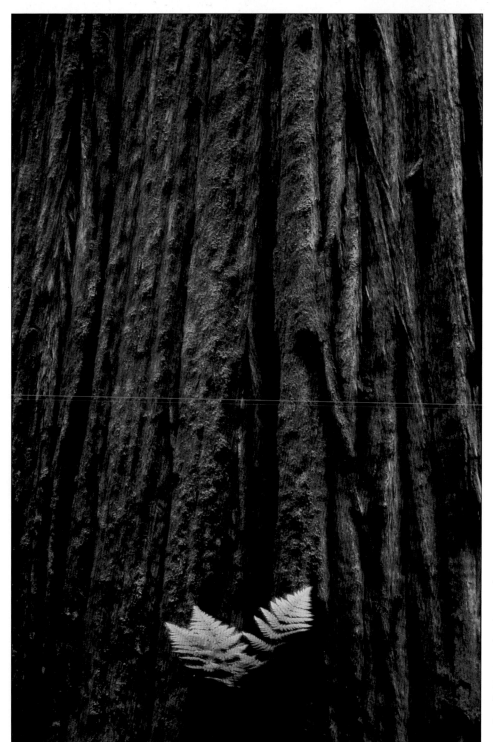

There is

no substitute

for time

spent

seeing.

For a landscape photographer, there is no substitute for time spent seeing, and while we are in this mode, opportunities present themselves in various ways. Both of these images (left and opposite) are similar in that the primary subject, though small in relation to the rest of the picture space, undeniably attracts our attention. The differences lie in how this was achieved.

To heighten the sense of drama and emphasize the somewhat translucent fern's placement against the roughly textured redwood trunk, I made a slide sandwich. The very slightly out-of-focus color component was one stop overexposed at F4, while the in-focus component, after compensating with a slight zoom to insure proper indexing, was also one stop overexposed at F11. This dramatically increased the tonal difference.

In this image on the opposite page, the same concept is achieved through the use of a carefully chosen angle of view and the utilization of the surrounding daisies as diffusion. The slightest movement shifted these areas in the composition, supporting the presence of one stranger in the midst.

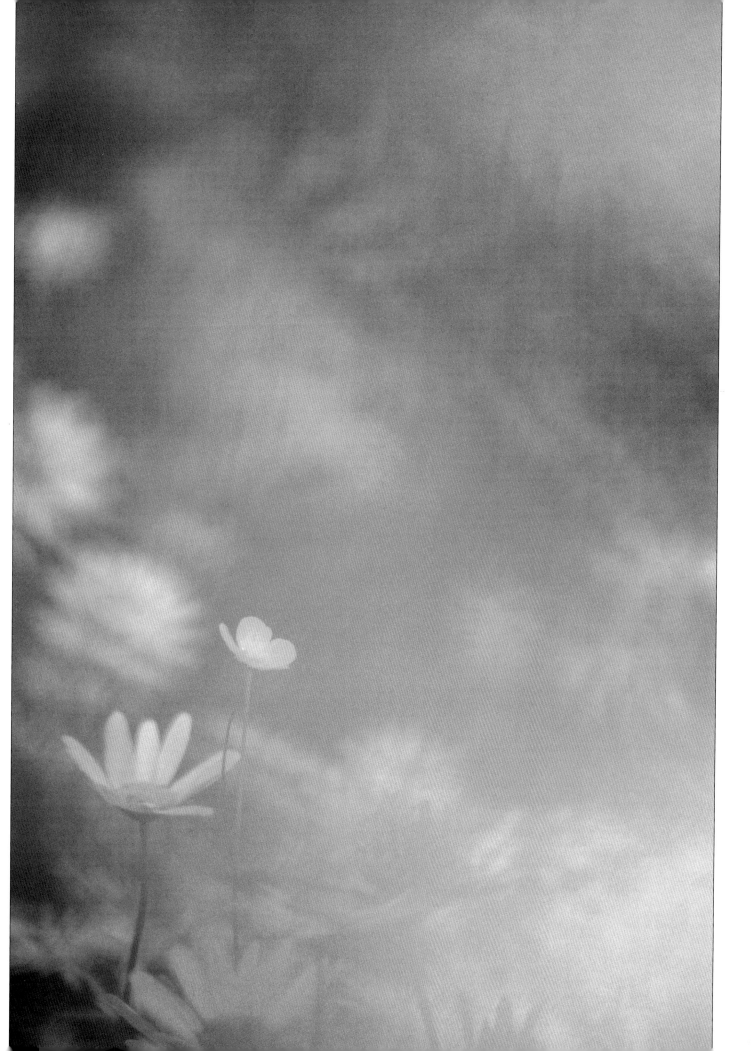

2.
The Creative Conversation

A CREATIVE PHOTOGRAPHER CONSISTENTLY EXPLORES OPTIONS and senses opportunities to transform the everyday into that which often transcends mere reality. But how does he do it? What steps does he take, and why? Let us consider the creative photographic process in its most distilled, simplest form. The essential elements of creativity form what I refer to as a three-part cycle, each dependent upon the others.

The first component of the cycle is Vision, the recognition of that which has captured our attention, the visual qualities of our surroundings, our "raw material," so to speak. We then take this information, process it, and begin our inner conversation consisting of questions and answers. We identify the photographic choices or responses that will best convey our impression, mood, theme or concept. We clarify how we feel, and how we are affected by what we see. This is the Imagination segment of the cycle. The third part of this cycle is the component we most often neglect to recognize and nourish. This is the fuel, the catalyst of the cycle. Our motivation and persistence to explore our capabilities in Vision and Imagination will not flourish without Passion.

These three components form a seamless cycle; each element feeding from the others. As our Vision becomes tuned, our Imagination grows more creative, and our Passion, resulting from the sense of fulfillment, drives us to explore and create more and more, upward and upward.

Transform the everyday into that which often transcends mere reality.

This cycle is only a simplified tip of our creative potential. Given the freedom of exploration, our photography can go beyond the creative and ultimately become inventive. Let's individually examine the three parts of this creative cycle—Vision, Imagination, and Passion—and explore the components of our own Creative Conversation.

No two of us are exactly alike in our choice of subject matter, the raw material we choose to shape into our images. The way we see is the product of our lives and attitudes, and, all too often, we may have become set in a pattern, seldom deviating from safety and convention. For example, two people walking the edge of a pond with yellow irises growing in it will likely respond differently to what they see. While one is attracted to the red-winged blackbirds noisily flitting from stem to stem, the other is captivated by the abstract reflection of the irises and clouds on the water's rippled surface. The obvious possibilities are usually just that: obvious. The numerous, subtle options aren't always as apparent. No one is capable of recognizing every potential image—no one should expect themselves to be. There is, however, a great deal of truth in the notion that the more time we spend seeing, the more we will see.

We are told that seeing creatively involves an ability to remove labels from the things we observe, but you may ask, If I do that, what am I looking for? What am I looking at? This is where we need to think like artists instead of documenters. Let's consider a tree, for example. Many visual qualities make up a tree, and these qualities are constantly changing, even as we observe them. The tree's trunk may be wonderfully textured or patterned and many-colored. An ecosystem of mosses or lichens may exist on it. Is the trunk sidelit or shaded? Is there a shadow on the ground beneath the tree? Does this shadow interplay with other shadows? Can the shadow be seen from up in the tree? How does the tree affect the earth beneath it? Are there fallen leaves or cones laying in patterns? Now, looking up into the trees, do the branches form a pattern as they splay outward from the trunk? Do they contrast? Are there random patterns in the leaves against the sky? Are the leaves translucent? What is the light doing to them? How would different light affect this? If the leaves are translu-

The way we see is the product of our lives and attitudes.

cent, does their structure form patterns? How about their edges and stems? Is this a single tree with space surrounding it, or one of a family? How do they fit together as a community? Are there differences in the shapes and textures of the members of this grouping? What surrounds them? Are they silhouetted? Do the trunks form a repetitive pattern? How does the weather affect them? Is the wind moving their branches, their leaves? How will they appear in the spring? Summer? Fall? Winter? With snow? With rain? At sunrise? On a misty morning? Does this tree have a personality? If this is a solitary tree, can its isolation or its triumph against the odds of survival be portrayed? If this is a flowering tree in spring, have I conveyed the joy in the renewal of life? If it is strong and dominant, have I displayed its power over the other trees around it? If it is vulnerable and oppressed for light and food, are these qualities revealed through my composition?

Looking is observing without becoming involved. Truly seeing requires the emotional and physical immersion of ourselves, even if in an imaginary sense. Instead of asking, "What is this?" try, "How does this makes me feel?" Even a tree can conjure emotion. A solitary pine silhouetted high on a rocky ledge evokes a feeling quite different than an apple tree in blossom within an orchard. As you can see, a tree can possess many visual qualities. Now, let's revisit the pond and explore a little further.

It is a bright day, the sky is blue, and a few clouds are scattered across the expanse of sky. The colors in this scene are vibrant today, and the yellow irises amidst the spring greens and blue waters draw us closer to the pond. The beauty of the colors in this scene is our first and most obvious attraction, but it should prompt a cavalcade of others. Because of the bright light, sky, and clouds, the water is alive with many moving, pulsating, reflected patterns. The slender green leaves and brilliant yellow flowers swaying on their stems are almost luminescent because of their translucence in the sunlight. There are shadowed areas of darkness in the water on the edges of some of the iris clusters. The flowers, viewed at a distance in a particularly dense area, form a pattern amongst the greens. Patterns of rings are rippling outward from splashing ducks. Could a

Looking

is observing

without

becoming

involved.

Patterns

of rings

are rippling

outward

from

splashing

ducks.

stone be used to do the same? There are numerous edges, stems, and flowers to explore with a macro lens. The clouds move and the light becomes bright shade. The breeze shifts and alters, affecting the surface of the water. The stems and slender leaves sway back and forth as the spaces between them open and close. As we kneel down, the moving irises become a curtain of diffused color, a wash to peer through. We can visualize the pond on a rainy day with soft light and raindrop rings on the water, then on a cool morning with a soft mist. The rising or setting sun would impart a wonderful reflection of color on the open spaces of water if there were a few clouds. There are some aged, twisted oaks on the edge of the pond that could form eerie shapes given the appropriate light. As we skirt the pond, the sun's angle begins to lower and shadows to lengthen. The reflected sun bounces liquid light off the water. Imagine the pond on an early winter morning with rings of ice attempting to capture the weathered stems. This creates a mood quite different from the glory of spring when flowers and greens dominate the scene. Exploration, recognition, and visualization can take us beyond obvious labels, not only with objects we label, such as trees, but in more diverse landscapes as well.

A list of visual qualities could include:

✣ Color	✣ Motion
✣ Quality of light	✣ Weather effects
✣ Direction of light	✣ Translucence
✣ Patterns and textures	✣ Sunrise/sunset
✣ Reflections	✣ Shadows/tonal contrast

When we begin to perceive our surroundings in this manner, we will cease to produce predictable photographs; our imagery will spring to life, and will begin to assume new creative dimensions.

There will come a time when you will be able to select a theme, mood, or concept, and with knowledge of the raw visual elements available, can select and arrange them to communicate your vision. This is what photography is really all about: expressing yourself with effective visual design. You might create and keep an up-to-date file that lists the available visual elements you'd like to photo-

graph, and in what season, weather conditions, and time of day they can be found. The ability to be creative and capable of expressing ourselves visually is proportionate to the time spent in expanding this awareness.

Let's review our raw materials, those that have attracted us and prompted our excitement to become involved and to photograph.

COLOR

Our attraction and reaction to color—a powerful visual quality—is largely instinctive. What are the feelings that red, yellow, green or blue evoke in you? The way we see color is affected by the soft or harsh quality of light. Color is evident or absent in all landscape forms, shapes, lines and textures or patterns, and as such, affects the way we arrange our compositions. We can use color extravagantly, photographing a field of blood-red tulips, or subtly, producing an image of a single yellow buttercup amidst diffused white daisies. Against darkened woods, a single drop of contrasting color immediately catches your eye. Colors can be harmonious—a grouping of related hues that evoke a sense of peace—or can be contrasting, introducing vibrancy and visual excitement. Nature's palette of color represents every imaginable hue. Being aware of the subtle differences in shades and predicting how they will respond on film is our challenge. As we move to the next phase of our creative conversation, we will learn that we have the option to saturate, desaturate and blend colors in painterly ways. The color we see prompts us to ask ourselves, What would an impressionist do in this situation?

We have the option to saturate, desaturate and blend colors in painterly ways.

QUALITY OF LIGHT

From harsh, direct light to subtle, soft, overcast light, our individual responses to the landscape differ considerably. I admit to preferring soft, diffused light, and the resultant even saturation of colors, lack of garish hot spots and washed-out details. From intimate close-ups to larger landscapes, I can see, in the purest sense, more deeply, often discovering qualities I might have otherwise overlooked. However, our task is to use the opportunities that light presents to us, and not to prejudge what we may encounter. Harsh light can create translucence, reflection, and

powerful, strong shadows—all excellent dramatic visual elements. Coming to know the difference between the way film responds to harsh and soft light, and making the transition with our eyes and mind, is an illuminating creative milestone in our development as creative photographers.

DIRECTION OF LIGHT

In the rising and falling hours of daylight, we can affect the direction of light simply by turning around. As well as simple backlight, sidelight and frontlight, other combinations present themselves as we, and the sun, move. Frontlight, which comes from behind us, is a flat, shadowless light; sidelight emphasizes textures and shadows, and backlight silhouettes and accents edges. As you explore the landscape, begin to use your mind's eye to apply imagined directions and qualities of light onto the scene as you see it. Visualize backlight and sidelight, shadows and edges. You will find yourself returning when the light is exactly as you imagined it should be. You will begin to photograph with intent and purpose. You will take control of your photography, rather than letting chance dictate success. This will give you a powerful feeling.

Use your mind's eye to apply imagined directions and qualities of light.

PATTERNS AND TEXTURES

Patterns and textures are all around us, and can be the basis of wonderfully creative images. Texture is the feel, the roughness or smoothness we perceive in the landscape, whether a grassy field, a stony beach, or the bark of a fir tree; the degree to which that texture is evident is often a result of the direction of light. Patterns can be composed of a random placement of shapes or constructed by predictable, repetitive shapes—a parallel grouping of tree trunks, stems of cattails, daisies in a grassy field, or motion rings on the water's surface, for example. Does our visual need for organization draw our eyes to these qualities? The texture, pattern, or both could provide our primary attraction to our subject. We could use either texture or pattern in a supporting role with the introduction of a secondary form or shape, for example, a tiny plant amidst a rippled sand dune or a red vine maple in a grouping of white birch trunks. We are capable of taking this raw material and shaping it with our photographic choices, emphasizing and blending various patterns, particularly regular ones

such as parallel shapes and circles. We can also darken shadows within textures and patterns, and in doing so, give a dramatic edge to both. Recognizing patterns and textures plays an important part in developing our creative pattern.

REFLECTIONS

"Alive and fleeting" is the best way to describe this visual opportunity. Often, the reflection itself can be the primary focus of our attention, for example, fall color echoed on a lake or river, or color used as background when orbs of light are bounced off the water and through the shoreline leaves or grasses. Snow and ice are also effective reflectors of light. Reflection can change with a slight change in our viewpoint; we must never assume that we have seen the best view without moving. Color washes and reflections can be combined in "sandwiches" (as will be discussed later), rendering impressions of living light. With each of us viewing from our own vantage point, creativity becomes a unique reflection of our vision of the landscape.

MOTION

Though one of the often unexplored among our visual opportunities, motion is one of the most evocative possibilities. I constantly hear and read about photographers waiting for hours for a moment of stillness to accurately depict a flower. For the expression of pure freedom and joy, however, there is no finer symbol than flowers in syncopation with the wind. Our world is alive, it moves; water, clouds, grasses, leaves, and sand are not frozen in time. Let yourself be enticed with motion, and let it breathe life into your images. Your creative photographs are expressions and impressions; here is a chance to ride the wind.

WEATHER EFFECTS

As weather influences and effects the moods of the landscape, ever-changing visual qualities become apparent. We are compelled to react to the motion of falling snow, billowing storm clouds, enveloping mist and fog, replenishing rains, attacking lightning and angry seas. These are the personalities, the faces of the landscape at its finest. My most memorable days of photography were inevitably filled with changing weather, and they passed all too quickly. Weather effects change the familiar into windows

Often, the reflection itself can be the primary focus of our attention.

of opportunity, into fleeting visual moments in the context of the span of the years. Visualizing how the weather has transformed a familiar landscape nearby, you begin to take control of your imagery, and your creativity, unlike the weather, becomes predictable.

TRANSLUCENCE

A wonderful, yet often neglected visual quality, translucence can be subtle or striking as light passes through leaves and flowers. Both harsh and softened light can create this effect, but the resultant color and presence of shadow will differ. In Fall, a complete maple can glow with light, or a single leaf can be transformed, illuminating the detail within. While ice can be translucent, the varying transparency of moving waters can direct and refract light into submerged stones and sand ripples, producing flowing abstracts. This, to me, is "living light," and ultimately, my impression tries to communicate that feeling.

SUNRISE/SUNSET

To my mind, sunrise and sunset provide a source of light in a category separate from that of direction of light, simply because of the warm color of light they provide. All too often, we focus our attention on the source of the light, and neglect to take full cognizance of the effect of these moments on our complete surroundings. Although a clouded sky boiling with color is hard to ignore, that same blazing display is also being projected across the whole landscape, transforming the apparent color of everything in its path into a realm of hues often beyond belief! Areas of shadow and light can be emphasized, as you will see, and given even more drama through the use of sandwiching, to increase tonal difference. Preplan and visualize with sunrise and sunset in mind, and your use of this brief light will be anything but another sunset cliché.

Preplan and visualize with sunrise and sunset in mind.

SHADOWS/TONAL CONTRAST

While lines formed by shadows can form a significant portion of a composition, consider using shadowed areas as negative space—the shadows, as a component of the complete image, will naturally draw the viewer's attention to the illuminated areas. These images present themselves in fleeting moments, and therefore, the ability to anticipate

and to respond instantly is all-important. A darkened image with a glimmer of illumination is a powerful visual mix. As shown in the next chapter, subject matter with striking tonal variations (light to dark) can present exceptional creative opportunities, depending on our imaginative choices.

In looking for landscapes to photograph, we will encounter mountains, rivers, forests, dunes, valleys, skies, oceans, hills, and canyons, and we will recognize them as such. However, the ability to create with our photographic choices comes from seeing beyond these labels, selecting from the visual qualities and characteristics that change from moment to moment and from season to season.

Which of these qualities do you use in your imagery? I have pointed out and described the qualities of attraction for the gallery images in this book, and provided my appropriate photographic choices. Would yours be the same? Can you perceive other opportunities to explore within an image? We make choices constantly, that's what the photographic process is: decisions in relation to responses. We must constantly Recognize, Visualize, Realize. We are capable of making a certain number of photographic choices, of making a list of potential decisions with our cameras and equipment. The key to a Creative Conversation, in comparison to a documentary moment, is knowing and being fluent in our abilities to make and identify strong choices, to truly see the visual qualities we have talked about.

Let me share my definition of creativity: Creative images happen when we are aware of all that surrounds us, with all of our senses, and are able to respond with any or all of our photographic choices. I like to entertain the idea that we can be completely open, receptive and flexible in the way we perceive and respond with our cameras to the world around us. A lofty target, perhaps, or maybe just a matter of where we aim. Why not raise our sights? Could creativity be that close?

A darkened image with a glimmer of illumination is a powerful visual mix.

Gallery
Three

We will not necessarily respond in the same way each time we are presented with landscapes similar to those we have already discovered. Our creative thought processes evolve as we absorb more and more stimuli. While I could have arranged these moss-covered pine trunks in a tight parallel pattern, I chose instead to create an impressionistic image by utilizing a carefully rehearsed and executed camera motion stroke. The successful creation of this image depended on the placement of areas of tonal difference between the trees, which emphasized their pattern. The technicalities? A $^1/_2$ second exposure, one-half stop overexposed.

Our creative thought

processes evolve....

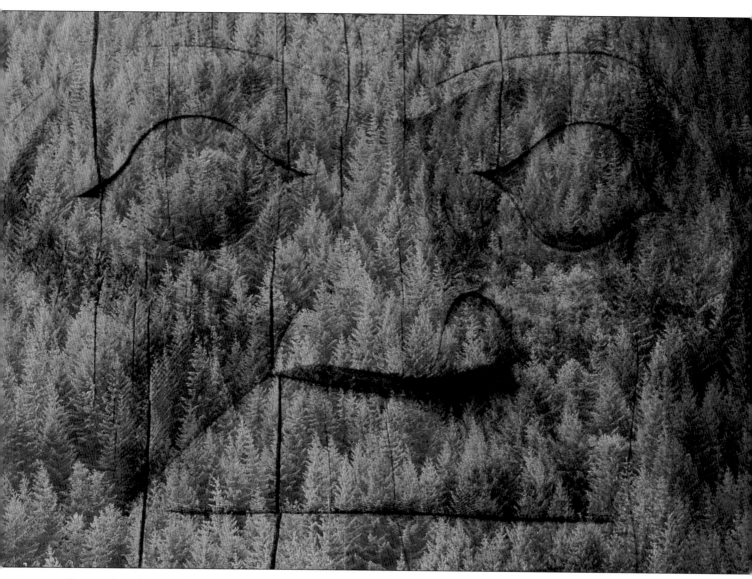

On another day, I might have created a double or multiple exposure, or an out-of-sync slide sandwich of this finely textured hillside pattern, and further emphasized its impression on me. It became, instead, one of the two textured components that I sought in creating *Face of the Forest*, an image composed of the hillside sandwiched with an image of a weathered totem, a representation of native peoples' deep bonding to the natural world. Both images were overexposed to facilitate sandwiching.

Colors have powerful emotional effects that we, as photographers, can exploit and emphasize. Careful selection from a number of choices allowed both of these images (above and opposite) to move in this direction. After selecting this line of tulips, which were somewhat separate from those behind them, I made a color-block out-of-focus image, setting my point of focus in front of the closest flowers. This also enlarged the out-of-focus background wash, achieved at F4, with a one-stop overexposure. I then refocused on the line of tulips, zoomed slightly to maintain the image size, set the aperture to F4, and made a $1^1/_2$ stop overexposure with slightly less color. The resultant sandwich embraces the floral chorus I had visualized. The soft light emphasized the saturated colors inherent in this scene.

The soft light emphasized the saturated colors.

Though similar in color, these maple leaves impart quite a different emotion. By moving beneath the tree and looking upward into the surrounding dark firs, the red leaves become dramatic. Do the out-of-focus leaves add or detract from this image? The striking contrast between the leaves and background caught my attention.

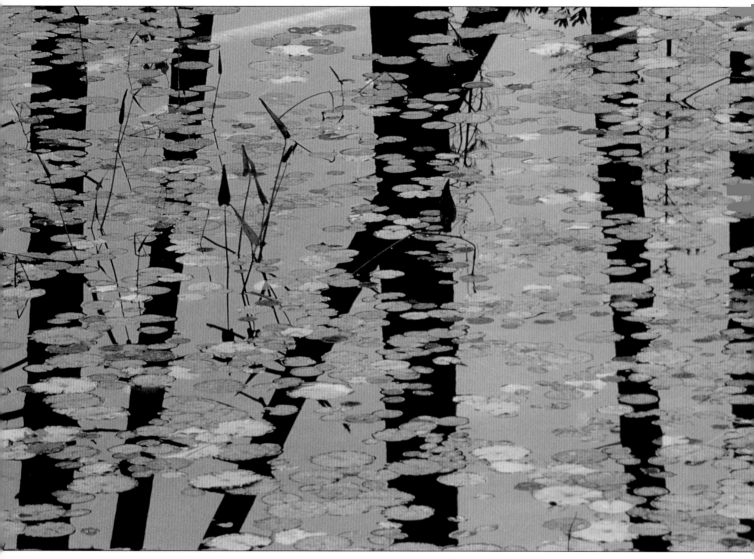

The visual qualities of landscapes combine in innumerable ways, sometimes resulting in a desirable final image; on other occasions, these components are filed and ready for use in future images. In the image above, the dramatic shadows intersecting the patterns of lily pads were arranged to my satisfaction under soft light. On the other hand, the subtle pattern of the reeds in the image on the facing page, etched on the soft reflection of a lake's surface, though graphic, felt incomplete because of the lack of color.

The visual qualities
of landscapes combine
in innumerable ways.

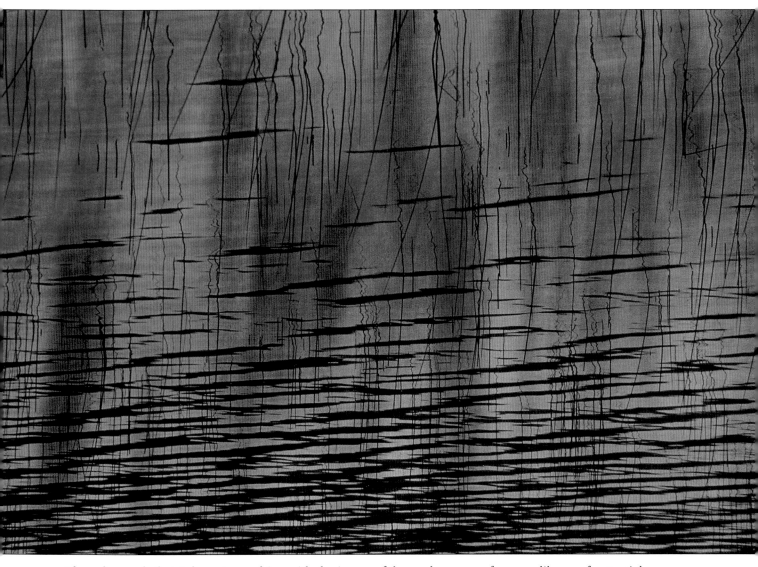

The color wash that I chose to combine with the image of the reeds was one from my library of potential washes. When creating the image, I used a camera motion that complemented the lines of the reeds, and overexposed one stop to create an ideal wash for later use.

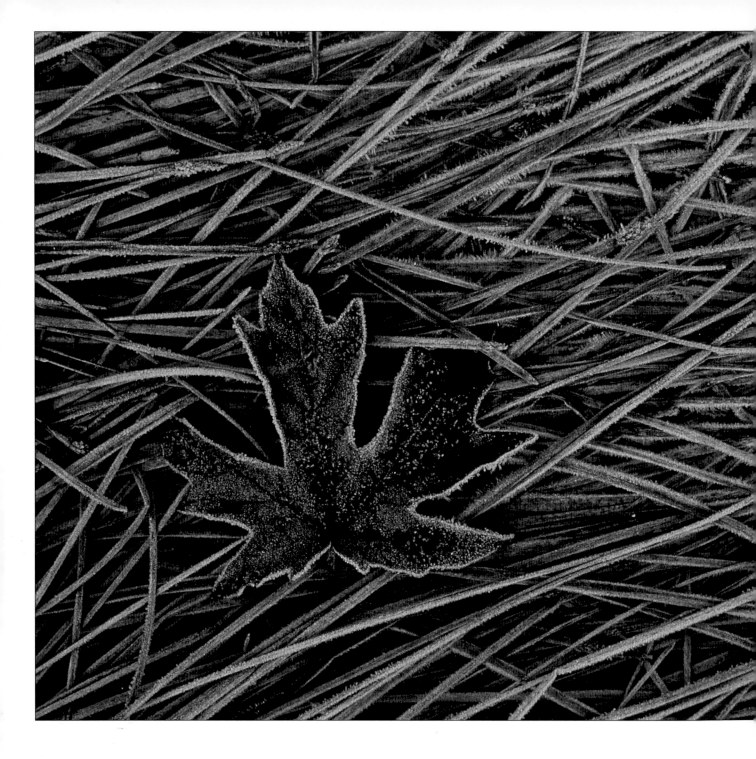

Structurally, these two images are similar. In the tumbleweed/sand photograph (below), the textural pattern of the sand ripples would nearly disappear if we were to take away the low angle of the sun and replace it, for example, with an overhead light source. Our eyes would not be led away, and, hence, back to the also emphatically illuminated tumbleweed.

The frosted leaves and grass (left), on the other hand, are rendered so because of very subdued soft light. Would this image work if these frosted edges were taken away? Now, change the direction of the line of the grasses. Add bright, direct lighting. Do these options add or detract from the image, or simply change it? Soft light, pattern/texture and tonal contrast are the visual keys to this photograph.

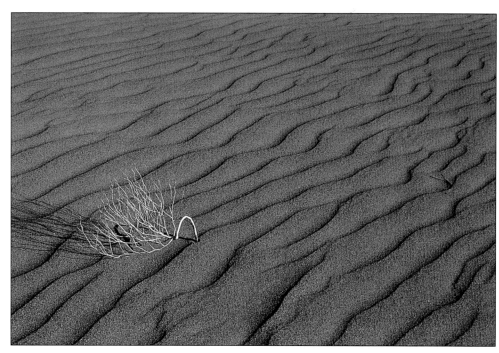

Changing light both provides and steals opportunities. To create the ideal opportunity, we must either adapt to the changes, or wait for the next change in lighting to occur. While perched on the roof of my truck (higher vantage point), patches of light moved in and out of the scene. I noticed the texture within the pattern of this colorful cabbage field, and waited for the predictable light of the next cloud cover.

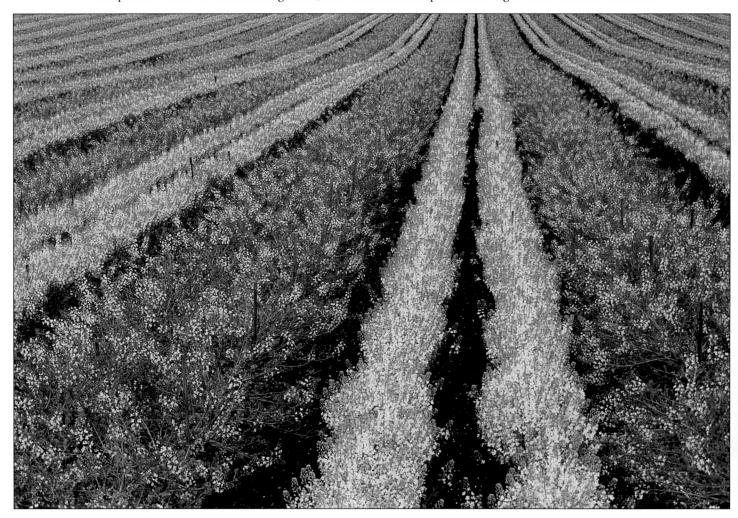

Dawn's angled light offered a window of only a few minutes as it rose and, all too soon, illuminated the background, stealing the tonal difference from the shadowed trees behind. There was no time to waste in responding to the translucent, backlit, high-contrast visual qualities of this opportunity.

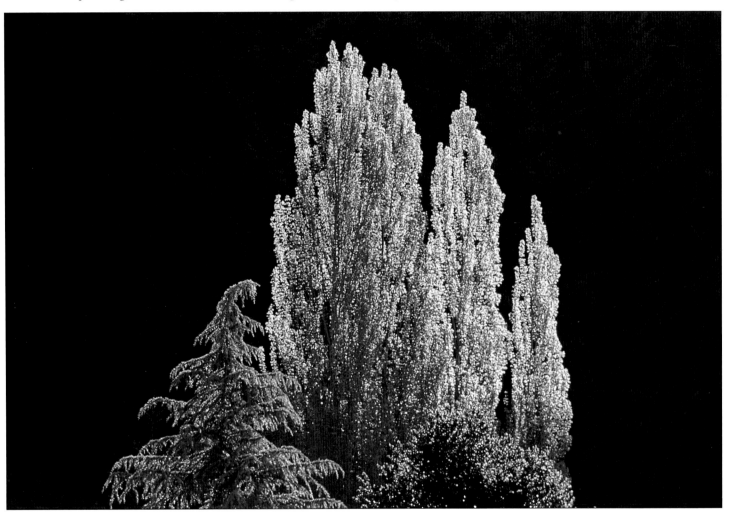

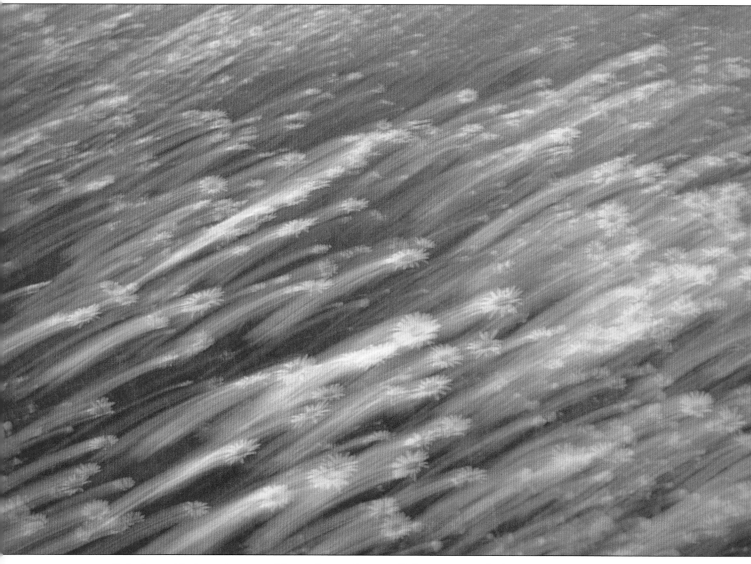

Painting with our photographic tools requires that we let go of some constraining mindsets that we may have held for some time. By rehearsing various camera strokes, I could easily predict where the motion trails would appear when the film was actually exposed. This particular image was the result of a one-second exposure, resulting in a one-stop overexposure. I began this exposure with the camera held still, and stroked obliquely for the end of the exposure. My attraction to the random pattern and subtle color of the daisies under soft light led to many photographic responses this evening.

I began this exposure
with the camera
held still...

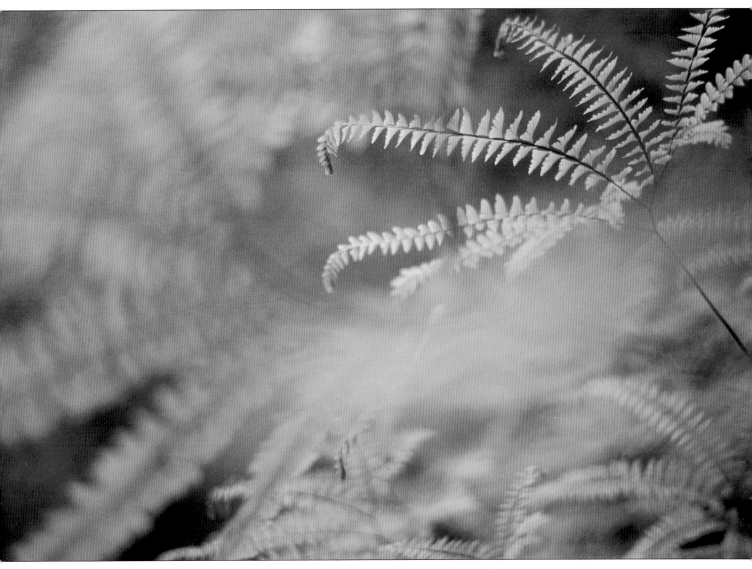

To compose this springtime image, I assumed an awkward angle of view beneath the adjacent ferns, creating a diffused wash that supported the distant fern. The degree of contrast—the background is somewhat darker, and the leaves translucent—added to the vibrancy of these colors. A number of attractions—vivid color due to translucence, the soft light and diffusion, the radiating pattern and tonal difference of the leaves and background—factored in my decision to stop and photograph.

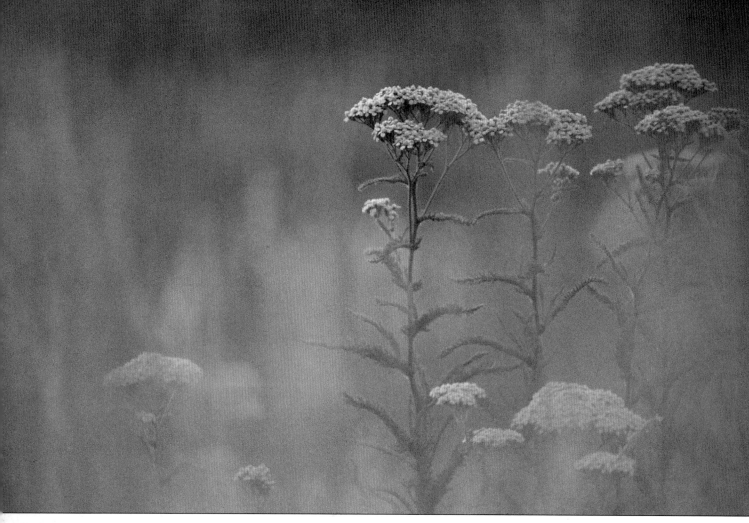

The subtle effect of soft, indirect light is evident in both of these images (above and opposite). In the photograph of the summer yarrow (above), the soft light enabled me to utilize the surrounding grasses as a diffusion wash. Working at a low level and moving to open "windows," with my 70–210mm lens set at F4, I was able to arrange compositions of this subdued, complimentary screen with the contrasting yarrows.

The subtle effect of soft,
indirect light is evident...

The subtle variations of color on this hillside in New York were made apparent by the soft, indirect light. The partially bare trunks and branches play a part in the final image, appearing as intricate stitches holding this wonderful quilt together. Strong light would have created shadows, and hidden these details from view. The complex texture, pattern, and restrained colors drew me to this scene.

Strong light would

have created shadows...

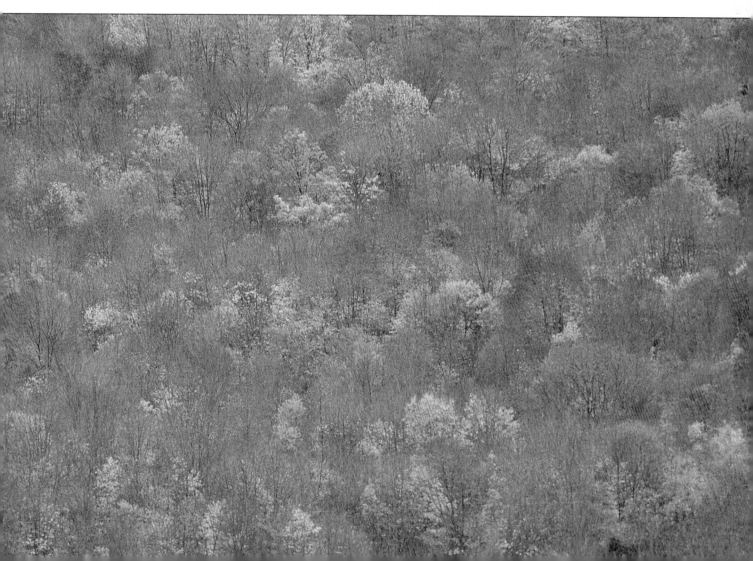

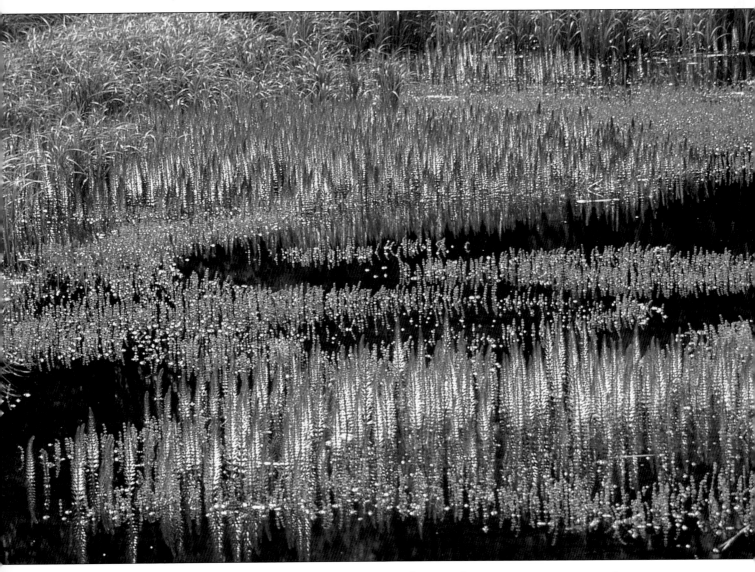

Choosing an appropriate filter is an important consideration when we decide on how to best portray the visual qualities of any landscape. Here is a dramatic example of the effect a simple polarizing filter can have. The option to use any of the many filters that are available to us should be carefully considered in many photographic situations. The photo above was taken without the polarizing filter, while the one on the facing page was taken with it.

Choosing an appropriate filter is an important consideration...

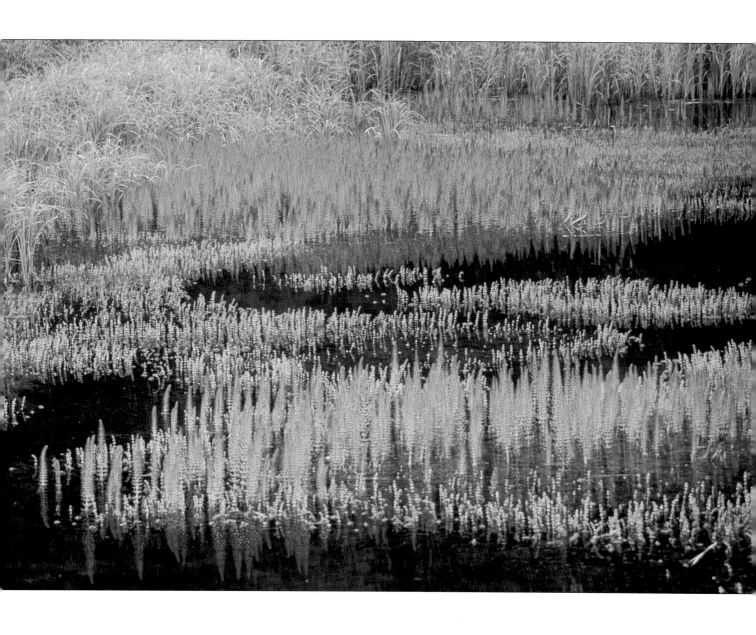

GALLERY THREE
59

We are constantly surrounded with raw visual material, and the way we choose to shape them is our prerogative. Tools and techniques are only decisions to express ideas through, and as such, I will use any approach I can get my hands on and mind around.

The photograph on the left is very much man-made—the refraction of a mass of cosmos through a clear, obscured glass building block. I was able to twist and shape the colors and points by taking advantage of the angle of light refraction into a macro lens. Does this make the image any less expressive of the flow of floral color?

The image below is, in fact, the frost on the inside of my truck (since window frost rarely happens on my home's thermal windows), created with my own breath and my neighbor's Christmas lights. Does this detract from the joy and vibrancy of the image?

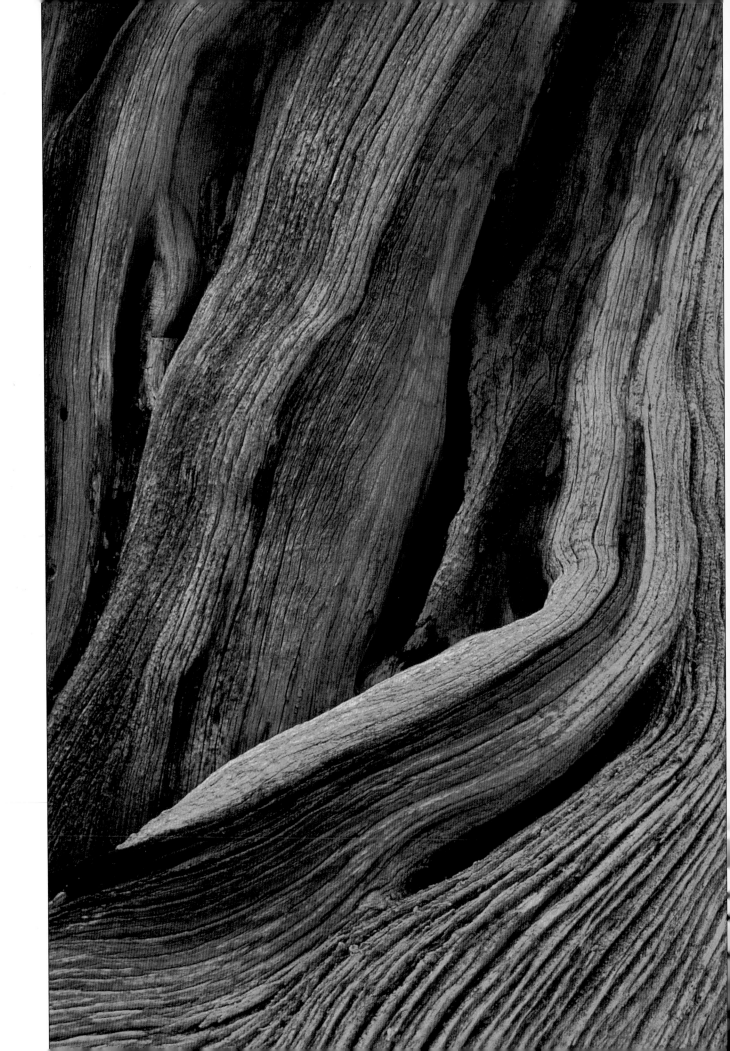

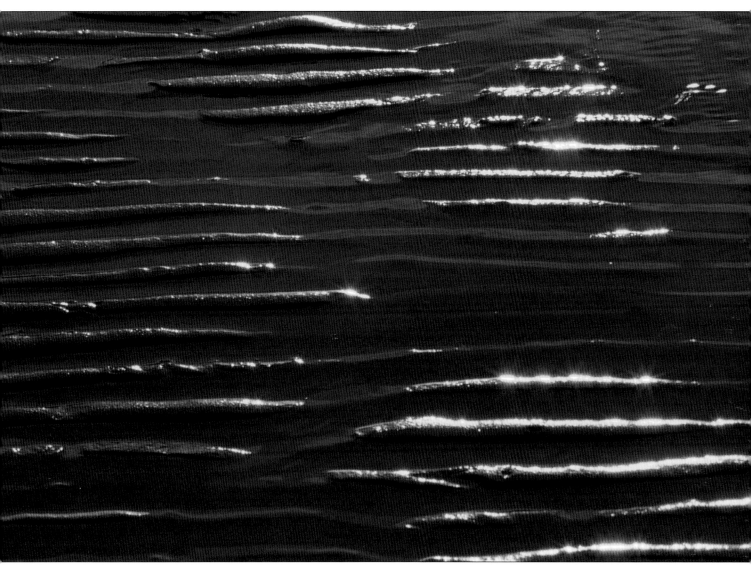

Reflected light is evident in both of these images (above and opposite). This highly textural weathered tree trunk (opposite) is bathed in the warm light reflected off of the colored clay composite of Bryce Canyon, providing nature's own warming filter. The photograph above is simply an image of wet sand ripples catching the first golden light of dawn. Reflections, like creativity, are transitional.

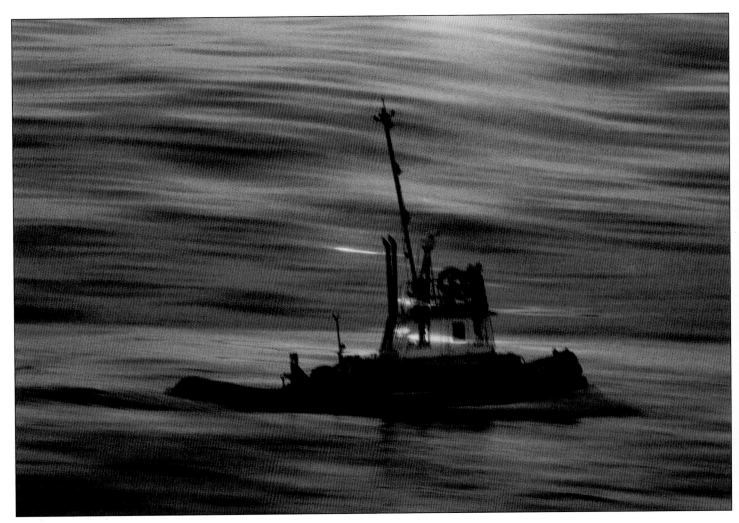

The camera is a window, a way of seeing, waiting for us to piece together the components of the landscape that lay in front of us. While watching this tugboat push its way through calm waters and reflecting evening light, I envisioned their combination. With the 70–210mm zoom lens, I first extracted a piece of the water's patterned surface, and then shifted to the boat itself, panned as it tugged along and "picked" it from the water. This impressionistic resultant sandwich captures the mood of the evening and indicates movement.

The camera is a window,

a way of seeing...

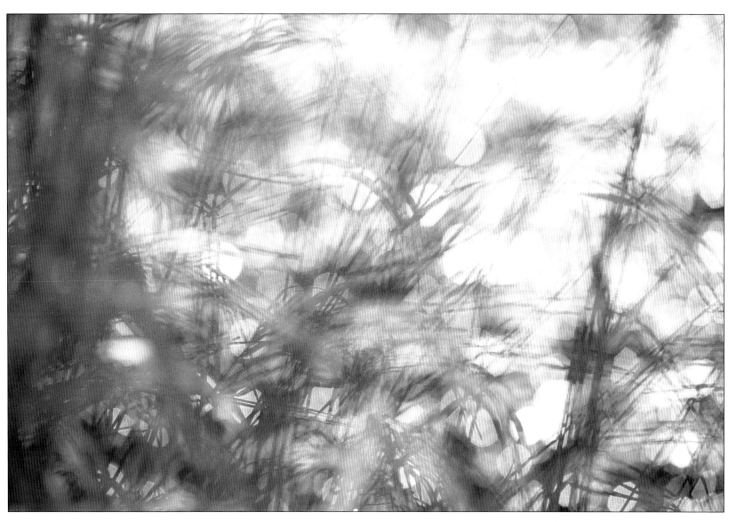

I was able to shape and

spread the light...

In *Wind and Light*, I was able to "see" in a way that my eyes alone could not. While studying the sparkling light that bounced from this pond as it passed through wind-driven, parched winter grasses, I was able to shape and spread the light, softening and shaping the wind's effect by focusing and overexposing at F4, just beyond the grasses. After all the reading and searching we do to find the answers to this puzzle we call photography, sometimes a decision just feels right!

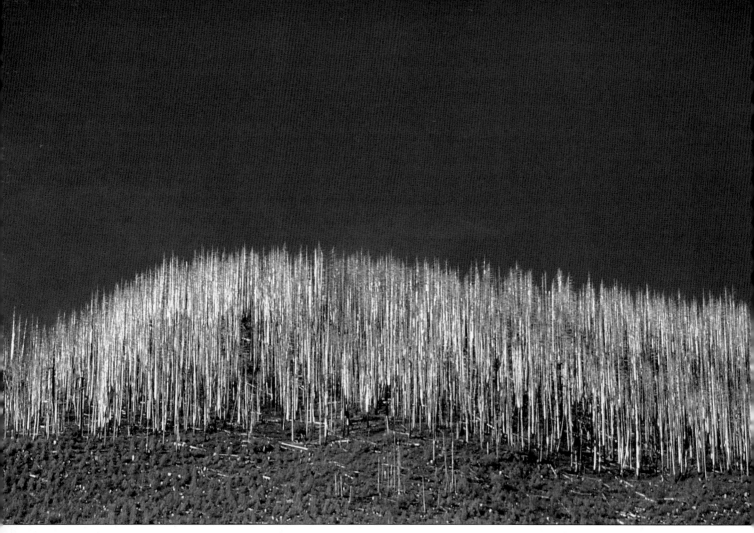

Allow yourself to explore at all lengths, employing each of the four lens groups' characteristics. Using the 300mm telephoto to abstract and isolate specific elements of this scene, I selected this slice of hilltop from the landscape. The descending angle of sidelight allowed for the effective use of a polarizer to "pop" the colors, especially the contrast between the band of silver and blue. The color placement, sidelight, and the pattern of the trunks in this landscape caught my attention.

Allow yourself

to explore at all lengths...

Macro exploration is

a wonderful opportunity...

At the opposite extreme, a 50mm macro lens was used in the investigation of this cactus. Macro exploration is a wonderful opportunity to enter worlds that we too often ignore. I set the aperture at F4 to achieve a shallow depth of field and a slight overexposure in order to emphasize the spines and simplify the still-evident symmetrical background pattern. Subdued light was a factor in selecting this scene.

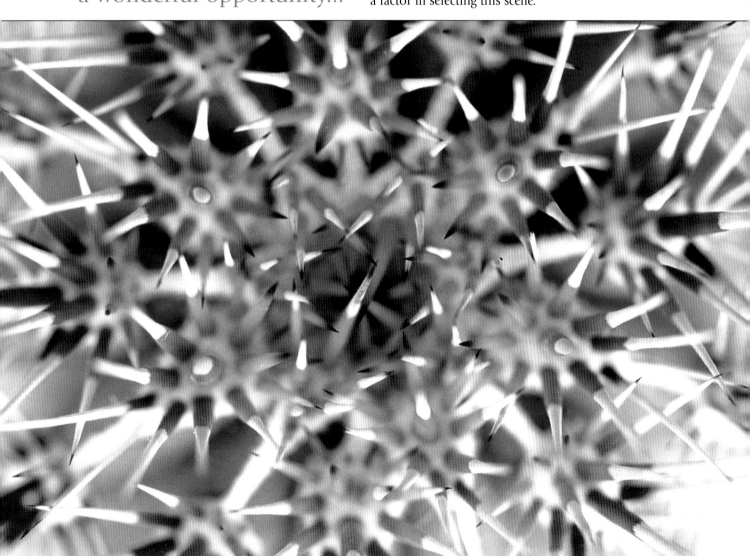

3.
The Conversation Continues

We have begun to recognize that, in any given situation, there can be many ways to see the landscape, and while sifting this information through our minds, we must decide on a plan of action to best portray our impression, its effect on us, the prevalent mood we are experiencing. A single word can sometimes describe what we are seeing, though we may neglect to identify it. Soft, tenacious, isolated, nostalgic, expansive, peaceful, rhythmic, pristine, powerful, diminutive, triumphant, joyous, delicate, and challenged are just a few. Our inner conversation ensues: I recognize these visual qualities, and sensing this theme, mood, or impression, will select and emphasize it with this approach (my photographic choice or choices). Consciously or not, we engage in this conversation every time we make a photograph. The difference between being noncreative and being creative lies in photographing a tree rather than its translucence, and merely documenting its form rather than elevating its celebratory qualities, its triumph. Typically, we make our photographic choices in a predictable sequence—we compose our image, choosing the elements we wish to include in the photograph, select the depth of field through selecting an aperture, and select our exposure, choosing a shutter speed for under-, over-, or "correct" exposure of our film. These three decisions are just the beginning. There are a number of other choices we

There

can be

many ways

to see the

landscape...

can make. How many of them do you now use? How many have you used in the past? Could you make a list? Would it look like this?

MY PHOTOGRAPHIC CHOICES/OPTIONS:

- Composition
- Depth of field
- Exposure
- Lens choice
- Multiple exposure
- Sandwiched images
- Zoomed exposures
- Flash
- Shutter speeds
- Camera motion
- Filters
- Diffusion
- Angle of view
- Films
- Combinations

In the ultimate creative day, we would encounter all of the visual qualities we have discussed, and interpret them with all of our photographic choices. Can you imagine the number of images you could make? Although this will likely never happen, we must constantly be aware of our numerous options, and be able to make these choices when the moment demands, so let us examine each briefly.

COMPOSITION

The decisions we make to assemble colors, shapes, lines, textures and patterns within the picture space can be an academic endeavor or an instinctive response. Books have been written on this, and opinions on "correctness" are just that: opinions. I believe that the more we experience in viewing the many compositions in the various art forms, and the world around us, the better prepared we are to choose the composition, or starting point for composition, that we deem most effective. The components of landscapes that we use as our raw materials are recognizable as trees, water, meadows, mountains, and grasses—labels we

Can you imagine the number of images you could make?

have attached to them. Our cameras can become label removers, if we so wish, presenting these objects as simplified elements of color, shape, line, and texture or pattern. Often, by defocusing our lenses a small degree, we can transform our landscape into a series of color areas, and hence, consider our potential composition in its simplest structural terms. This may clarify our visual attraction, providing an opportunity to arrange these forms without their labels. Notice how a bed of flowers becomes a pattern of colored disks on a soft green backdrop, how an autumn woods becomes dark columns with sprays of interspersed color. I save several out-of-focus images, which can later be combined and used as color washes in slide sandwiches.

Don't be afraid of radical compositions, or nonstandard position of the primary subject (if there is one!). Creativity culminates in exploration and discovery, not repetition and adherence; remember, it is the search that matters most, not the destination.

DEPTH OF FIELD

Although images can be seasoned with a moderate depth of field selection, the most striking uses are of either shallow depth of field with a soft diffused foreground or background (or both), or extended depth of field with everything in the picture space sharply defined in detail. Telephoto lenses, 100mm and longer, and macro lenses are used at their largest aperture, F2.8, to produce soft foreground or background out-of-focus washes, while standard (24–50mm) and wide angle lenses at small apertures (F22) can render everything within the picture space, from the closest foreground to the horizon, in sharp focus. Which of these is appropriate to convey the feel of the visual attraction you are exploring? If F4 yields a softened background and F22 a detailed image, you have a decision to make. Don't let an F-stop stop you! Keep going back to why you are making the image. What do you see? Imagine using shallow depth of field and making a slide sandwich or double exposure of the landscape, focusing first on the background, and then on the foreground. When we begin to combine images and create washes, depth of field selection becomes a variable. Depth of field will be a variable when we begin to paint with light, as well.

Don't
be afraid
of radical
compositions...

EXPOSURE

I like to consider exposure in a different, less rigid way. I think of it in terms of adding light or taking light away, as an artist would with white paint. Consider making light areas bright or restrained, creating pastels or deep, saturated colors. What did your visual attraction tell you? Did you listen? Is your exposure choice compatible? To keep a bright scene alive, we add light; to keep a dark scene subdued, we take light away. To make an exposure choice, we must expose according to how we feel about the visual attraction before us. Once you begin to work with lighting situations in the extreme (backlight and reflected light) the range of exposure extends. "Correct" exposure is simply the starting point.

LENS CHOICE

While an artist must imagine his image, photographers have several windows to see through. Wide, standard, telephoto and macro lenses each have unique capabilities and characteristics. Have you utilized each one? Exaggerated depth perspective and depth of field? Accurate depth perspective and proportion? Compression and abstract selection? Have you discovered the miniature and potential for close-ups in the exploration of visual elements before you? I carry at least two bodies with 70–210mm and 28–70mm lenses, constantly alternating my window of exploration, and occasionally deliberately misapplying, like using a wide angle for a close-up. Each lens group is a window into creative compositions—open them!

MULTIPLE EXPOSURES

As with our other choices, the more aware we are of the visual qualities around us, the more apparent our choices become. With multiple exposures we can exaggerate, emphasize, and combine patterns and textures in many ways. We can even move the camera and recompose between frames, keeping a mental image of the previous composition, to fill areas or shape our composition. Mixing lens perspectives can blend a pattern and a close-up, for example. By varying exposures, we can determine to a certain degree the dominance of a particular component in the final image. These are some of the inventive channels we can explore.

Lenses each have unique capabilities and characteristics.

SANDWICHED IMAGES

We most often think in terms of two dissimilar images, like a sunset and tree silhouette meeting in this fashion, with a rather predictable result. However, when we realize that the raw visual elements we draw from are ever changing, along with the considerations we can make when combining them, a whole new creative playing field opens up to us.

The variables of composition, focus, and exposure can extract from the landscape painterly impressions, expressions deeper than the literal. For example, by taking a single white daisy close-up, overexposed two stops, and sandwiching the image with an image of an expanse of daisies also overexposed two stops, we convey a unique perspective of the scene. What if the single flower were out of focus? What if the expanse were moving, or painted with motion? We begin to see choices within choices. As you encounter textures, reflections, and color washes, ask yourself, how can I combine and utilize them?

One of my trademark techniques has been referred to as "Orton Imagery" by two of the writers at *Photo Life* magazine. It involves sandwiching two or three transparencies of the same composition together. One slide contains the detail component, in focus and overexposed, and the second and/or third is the color component, out of focus and overexposed. Photographers have been using slide sandwiches for a long time. All I have done is fine-tune my own version. A solid tripod is essential, as this technique involves manipulating focus and focal length without moving the camera. I use a 70–210mm or 28–70mm zoom at F4 or F5.6, creating an image with a shallow depth of field to make the first exposure. This image is a controlled amount out of focus (a variable) and exposed anywhere from "correctly" to two stops overexposed, depending on the image and my intent in the final sandwich. If you bracket the exposure, you will have choices when you get to the light table. Next, with my eye to the viewfinder, I slowly begin to bring the image into focus. However, as we all know, the image is changing size as it comes into focus, it is getting smaller. Therefore, as I sharpen the focus, I must also zoom to compensate for this. I find that con-

If you bracket the exposure, you will have choices when you get to the light table.

The idea for

this technique

originated with

my efforts to

imitate

watercolor

paintings...

centrating on the edge of the viewfinder is the simplest method. If care is not taken, the sandwich can be quite askew with areas of color not properly indexed with the details and lines.

The idea for this technique originated with my efforts to imitate watercolor paintings by simply placing the images out of focus. If you have seen pen and ink and watercolor combinations, you will understand where the inspiration to add detail came from. Each color responds differently to this manipulation. Lighter colors will expand when placed out of focus, and darker colors and areas will recede, so be aware of this as you refocus. These steps are the basic exposure and focus guide from which I would encourage experimentation. When using this technique, we are forced to ask ourselves questions concerning combined exposures, combined focus, and the resultant sandwich. We can even mask shadows and dark areas to create emphatic, dramatic images. In fact, with focus and exposure, we can choose and control the amount of softness and sharpness, color saturation, overall exposure, and tonal variations in many situations. The materials we need to create sandwiched images, in all combinations, are around us, just waiting to be discovered. Apply yourself to visualizing these marriages, and this will become a creative mind game more than worth playing.

ZOOMED EXPOSURES

We have all seen the zoom lens's effect on various subjects, and the resultant implication of movement. Now, begin to consider this choice as one of the painting options that are available to you. Combine zooming with moving the camera in other ways, and then utilize multiple exposures and sandwiched images. Combine two zooms in one sandwich. Vary the exposures of each of the images to create light and dark spaces. Begin to build a library of zoomed colors. Zoom in on reflections. Shifting the camera during a zoom can reposition the centre of the vortex to other locations within the composition. A zoomed image can be subtle in color and movement, or powerfully compelling. We have the control. Rehearsing and previewing our techniques help us to visualize the resultant image, and will carry us beyond predictable imagery. We are creating.

FLASH

We are literally painting with light when we use multiple flash applications to illuminate the landscape from different angles, with varying power intensities, and using complimentary colored gels on our flash units. Landscapes and subjects with lighter natural colors will make better reflectors with colored flashes and render the selected color gel more accurately on film. In other cases, the colored flash will combine with the hues of the landscape, producing a blended color. When using a flash, setting the camera on bulb and using an assistant to cover the open lens as you move to each flash application point is usually a good idea. We create the mood in our images with our choice of colors. Think about snow, sand dunes, birch trunks, cascading water, or white apple blossoms. Now think about how you could apply color in the form of light. We can also utilize light from other sources, for example, with handheld battery-powered spotlights or a smaller flashlight, in combination with our flash or alone.

SHUTTER SPEEDS

Long exposures of one second or more allow for the opportunity to paint landscapes, or for the landscape to paint itself, through motion. Slow films, a polarizer, or neutral density filter, and/or subdued light are the tools and keys to exploiting movement in the landscape. Motion constantly surrounds us! Wind and gravity affect the visual qualities of the elements we observe, yet we often discount or strive to avoid motion. When the winds blow, a four-second exposure can carry an image into the ethereal realm, nourishing our creative soul. Intermediate speeds of $1/2$ to $1/30$ of a second can paint motion in falling subjects such as leaves or snow, while $1/60$ to $1/2000$ of a second shutter speeds begin to freeze motion. There is no "correct" shutter speed! We have the freedom to choose either to free or capture motion!

CAMERA MOTION

Consider camera motion in this way: The landscape you see through the viewfinder is a canvas wet with paint, and the film in your camera is a blank sheet of white paper pressed against it. Any movement of your camera will result in the landscape being painted onto the film accord-

We create the mood in our images with our choice of colors.

ing to the movement. There are many motions that will emphasize or blend certain shapes and patterns in the landscape. We can stroke vertically, in a straight line, or introduce an elongated oval stroke. Freezing and then stroking in a short oblique motion creates a blur of motion on a flower pattern. Twisting the camera around an off-center axis creates a single flower surrounded by a flow of swirling color. A tiny circular motion will blend a background and soften a floral foreground into watercolor-like flow. Try simultaneously using motion and varying focus. With strokes, we can imply motion, emphasize lines, and stretch and blend shapes. Colors and areas of tonal difference will interact much as if we were literally painting. Rehearsal and visualization are necessary if we are to actively create rather than merely hope. In applying painterly motion to visual stimuli, you will not only tap your own emotions, but, in time, will create images that evoke strong emotions.

Try simultaneously using motion and varying focus.

FILTERS

Filters are the seasonings of our images, fine-tuning and giving an edge to our desired impression.

Here is a list of some common filters and what they can do for creative photography:

- Polarizers remove reflected light, saturate colors, and slow shutter speeds one stop.
- Cross filters soften and spread light.
- Warming filters (amber) accentuate warm colors such as red, orange and yellow.
- Cooling filters (blue) create moody images.
- Magenta filters "pop" sunsets, sunrises and reds, creating a more vibrant hue.
- Graduated and neutral density filters block light to balance exposure in specific areas of an image or throughout the entire image; these filters will slow the shutter speed.

In any situation, a filter can make or break an image, so keep in touch with your intent and your interpretation of the visual quality you are striving for when experimenting with filters.

DIFFUSION

Diffusion is a technique that uses natural materials such as grasses, leaves, or flowers as a wash of color. The landscape provides the palette; we need only explore and utilize the opportunity. By positioning these objects close to the camera and peering through a telephoto lens, using an open aperture (F4), and consciously shifting our viewpoint, we open ourselves up to new views. Screens and washes of color can be positioned to create complementary space, enhancing and emphasizing the primary distant subject. Creativity is enhanced by exploring beyond obvious walls, and even seeing through them!

ANGLE OF VIEW

Creativity involves calling upon and questioning many of our senses and capabilities, both individually and collectively. Landscape photography demands the blending of both mental and physical disciplines as we integrate ourselves into our surroundings. Our eyes, minds and hands shape our images, but our feet could be our most valuable tool! Remember to use the actions of seeing: stand up, sit down, crawl, look closely, look beyond, see through, look up, look down, look back, move forward, move backward, move around, ascend, descend, wait, rush, even squint. These are some of the actions of seeing, and whether we are in the forest, in the city, on top of sand dunes, in our flower gardens, or on the edge of a lake, they will map the road to new possibilities.

FILM

The images in this book were all made with 100 ISO E6 slide film. Since a photographer has the ability to shape, layer, saturate, soften, lighten, and blend the final image with other photographic choices, I haven't felt the need to carry numerous films. Slower speed films give us the opportunity to use camera motion and zoom choices, or to let the naturally occurring motion in the landscape paint itself. Of course, faster films are capable of freezing motion when combined with faster shutter speeds. You may wish to use a slower or faster emulsion for your own creative reasons, and that is fine. I do, however, carry a third body with 200 ASA black and white transparency film and a red lens filter to help me "see" in black and white. This is a

Screens and washes of color can be positioned to create complementary space.

valuable exercise in learning to recognize tonal variations, shadows, and highlights. Consider combining black and white with color transparencies.

COMBINATIONS

As we now understand the potential of each of the preceding fourteen options, we arrive at the ultimate of all creative choices at our disposal: the ability to combine these options. Given an ongoing exploration of subject matter, with ever-changing visual qualities and varying combinations of photographic choices to interpret and shape them with, our well of creativity begins to fill. We can paint, separate, select, wash, dilute, emphasize, highlight, superimpose, and shape raw visual material much as a painter would. These are freedoms that we can experience, visions we can pursue, and dreams we can realize.

These are freedoms that we can experience, visions we can pursue.

We can now use two components of our creative cycle. Let's consider them together.

VISION	IMAGINATION
Visual Attractions	*Photographic Responses*
❖ Color	❖ Composition
❖ Quality of light	❖ Depth of field
❖ Direction of light	❖ Exposure
❖ Patterns and textures	❖ Lens choice
❖ Reflections	❖ Multiple exposures
❖ Motion	❖ Sandwiched images
❖ Weather effects	❖ Zoomed exposures
❖ Translucence	❖ Flash
❖ Sunset/sunrise	❖ Shutter speeds
❖ Shadows/tonal contrast	❖ Camera motion
	❖ Filters
	❖ Diffusion
	❖ Angle of view
	❖ Film
	❖ Combinations

In a condensed sense, all that we need to know to be creative is on this page. Which of these attractions and choices have you used in the past? Which will you use in the future?

Gallery
Four

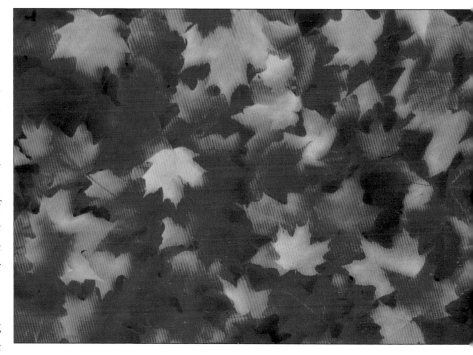

The extended control that slide sandwiching allows continues to be a favored area of exploration for me. In the photo to the right, I used it to punch the color of a carpet of fallen leaves. This photo was taken on an extremely dull, gray day, and yet, the colors sing. The color component, slightly out of focus, was two stops overexposed, while the detail component, in focus, was one stop overexposed, rendering sharper edges and details.

In the image below, I used sandwiching to restrain the light. I wanted to assure that the tree's trunk and limbs were dramatically darkened against the translucence of the backlit leaf canopy. I used a slightly out-of-focus image, one stop overexposed, and an in-focus image overexposed one stop to attain this effect. It was necessary to zoom in slightly, as the image size changes according to the amount of defocusing.

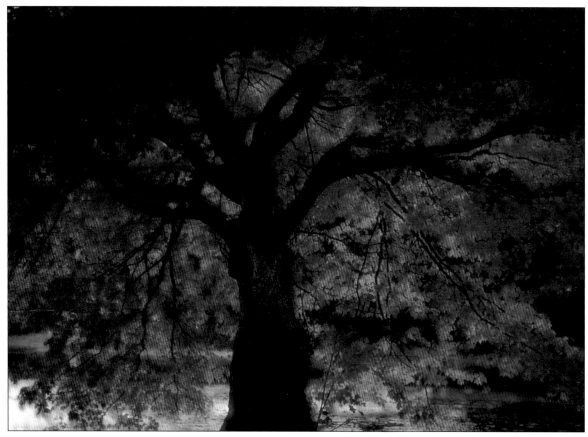

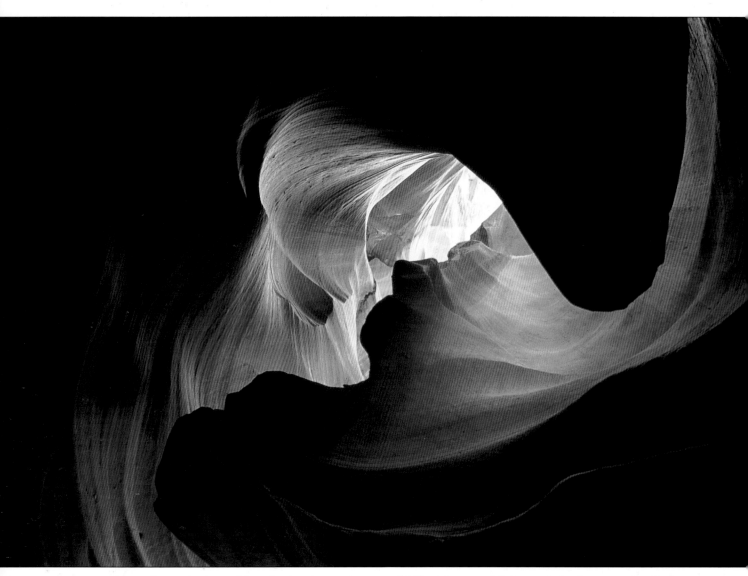

Sometimes photographing the landscape is an unfolding drama of light and shadow, one ineffective without the other, a balance of illumination and obscurity. For the image above, I twisted the camera and wide angle lens around and around, facing skyward, searching for the equilibrium of light and shadow in this swirled slot canyon. The reflecting light that visually warms the stones, and the supportive dramatic shadows were my key attractions to this composition.

To best portray the tenacity and triumph of these Sierra junipers (opposite), I chose a viewpoint that illustrated their ability to live on rock. Taking this composition one step further, and giving it an even more dramatic edge, I exploited the tonal contrast, the shadowed area lying between the trees, with a slide sandwich. To produce the first image, I focused on the area in front of the first tree, and utilized a "correct" F4 exposure. This slide provides the color component of the sandwich. For the second image, I focused just behind the first tree, set the aperture to F22 and overexposed $1^{1}/_{2}$ stops. The resultant image became the detail component of the sandwich. Sometimes drama happens, sometimes we create it!

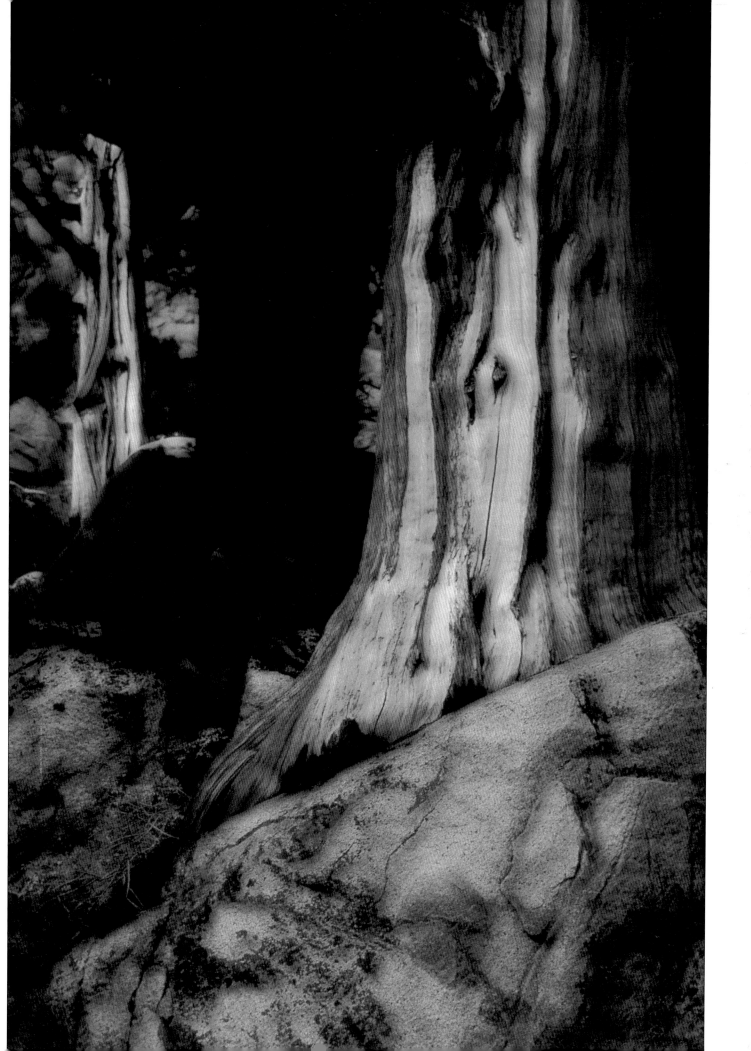

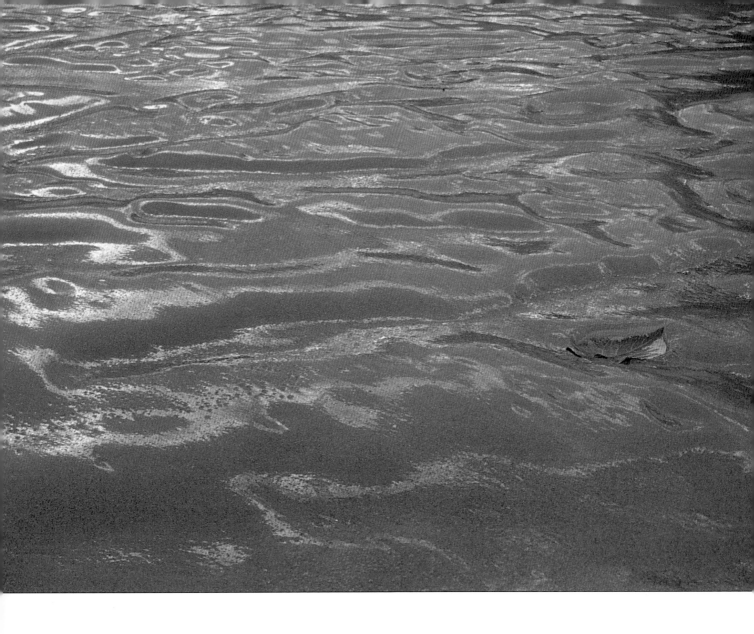

The seemingly infinite faces that water presents to us in its evolving forms gives life to our images, while supporting life itself. To discover this particular face (left), I had to assume an angle of view one foot from the ice, and use my camera bag as the tripod support. From this point, the patterned ripples, sky reflection, and a single captive leaf took their respective places in this discovery.

Water (in the form of frost) briefly transforms marsh grasses and a bull rush into muted colors (below). For a few moments before sunrise, nature's choice of line, texture, light, and hue is impeccable. My decisions seemed secondary. My initial attraction was to the textures, soft light, and restrained color, which I emphasized with slight overexposure.

...nature's choice of line, texture, light, and hue is impeccable...

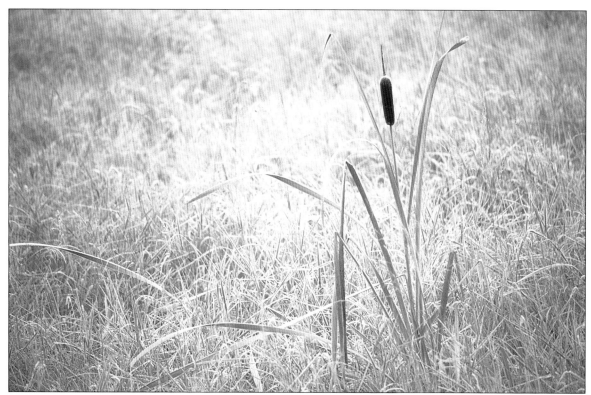

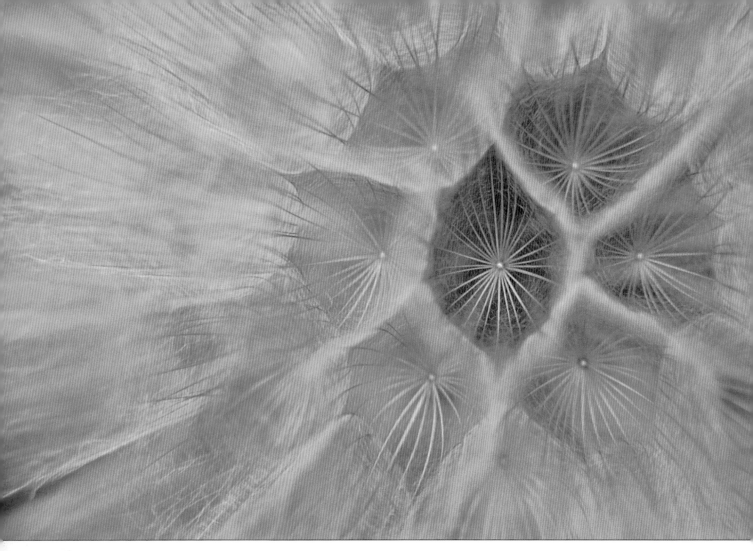

A moment of retreat from a fast-paced world may be one of the many benefits we derive from our photographic efforts. Perhaps it should be our first priority. The soft image shown above is an oyster plant photographed with a 50mm macro lens set at F4, and overexposed slightly. The detailed pattern was easily visible in the subdued light.

A moment of retreat

from a fast-paced world...

This image is a 70–210mm zoomed exposure. I took advantage of the fact that one daisy was central and remained essentially recognizable throughout the zoom. Once again, soft light and recognition of a pattern invited this opportunity.

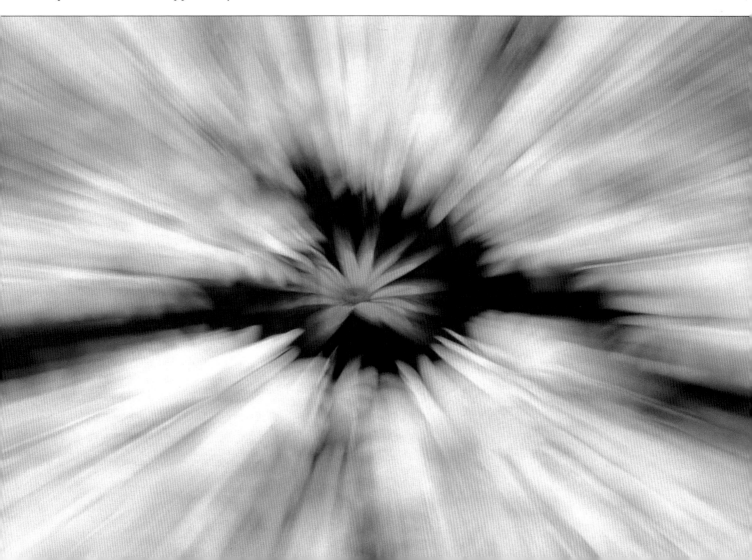

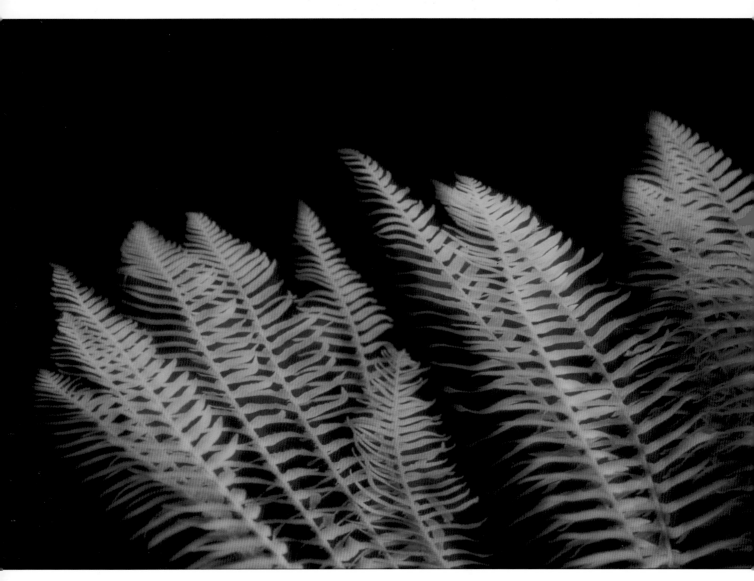

While shadows can provide dramatic backdrops to illuminated segments of the landscape, they can also create our primary visual attraction. This is an image of ferns (above) growing beside a huge fir tree that had been blackened by a fire. Sensing the opportunity to capture the tonal contrast under subdued light, I made a slide sandwich of two images. For the first image, I used a very slightly out-of-focus image, over-exposed one stop at F4; for the second, an in focus image also overexposed one stop at F4. When these two images were combined, the dark areas became darker and rendered the tree nearly invisible in the surrounding blackness.

Opposite, the shadow of a flower on the lily's translucent leaf was the result of a shoot in which I forced myself to photograph a bed of flowers under harsh direct light. The harsh lighting is generally not an attractive option for me, but then again, staying creative means continuing to explore.

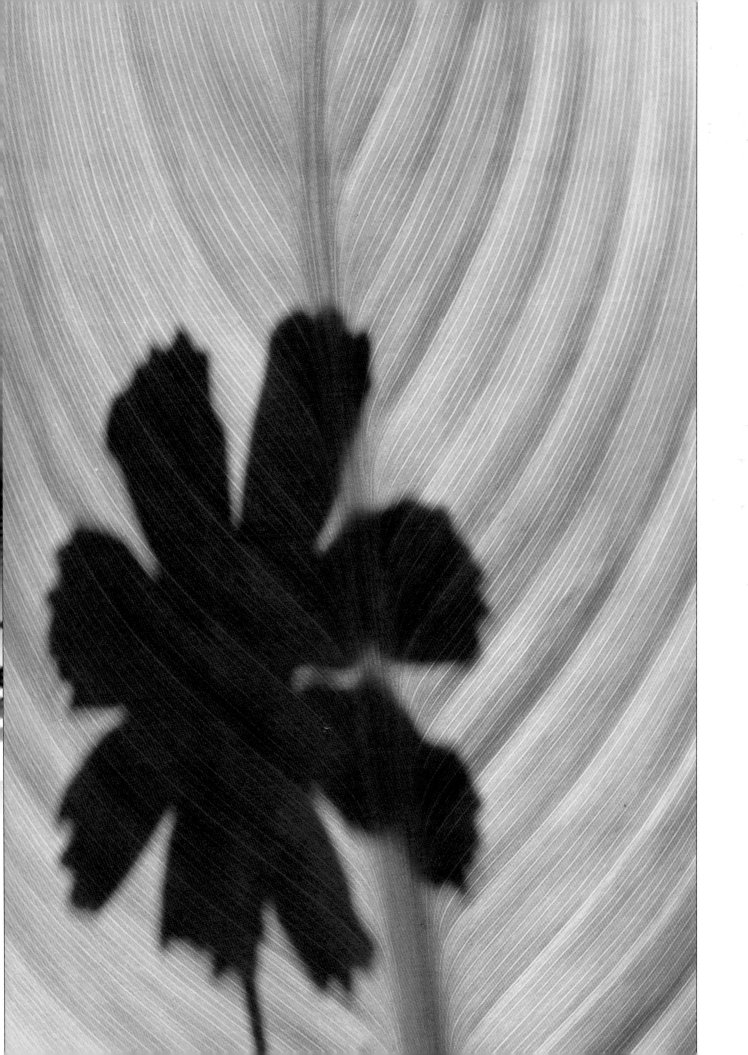

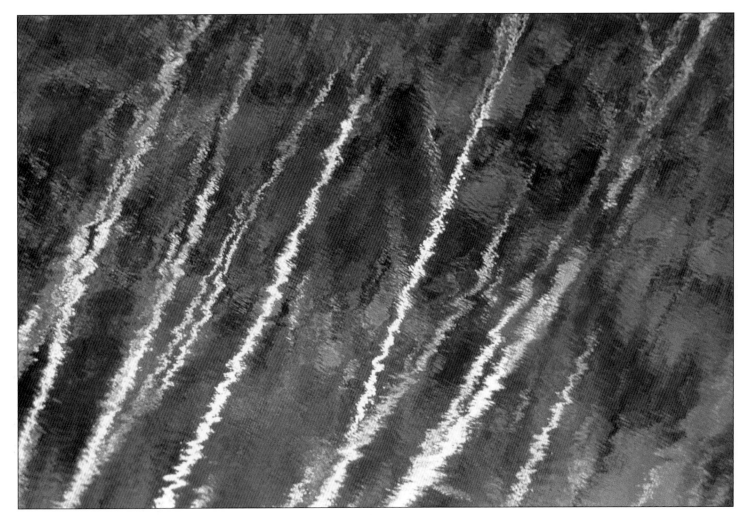

Motion is one of the aspects of the landscape that, unlike many photographers, I will actually seek out. To me, it is like interrelating with nature, responding to its touch. In the autumn reflection, each nuance of the breeze subtly shifted and shaped the colorful design on the water's surface. While the wind worked its wonders, I held my breath and overexposed slightly, retaining the white of the trunks and the bright hues.

To me, it is like interrelating with nature...

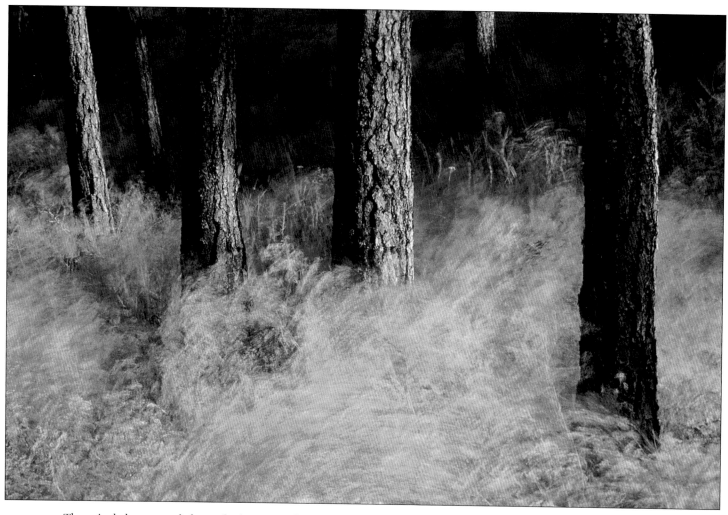

The wind that gusted through these ponderosa pines was not as subtle, animating the clouds of baby's breath surrounding them. I held onto my tripod and hat, and kept an uneasy eye on the wildly swinging branches overhead, making exposures of $^1/_8$, $^1/_4$, and $^1/_2$ seconds, evidencing the invisible force.

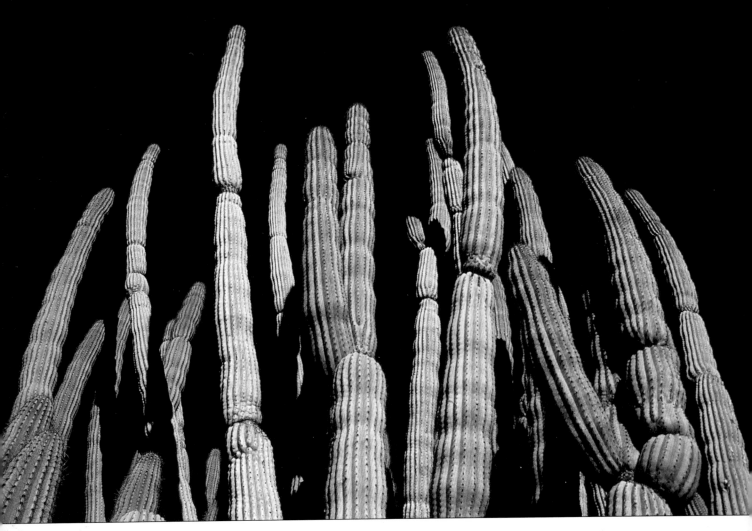

I don't carry a lot of different films with me when I shoot—I normally use Fujichrome Sensia. I believe that the basic differences between various films are minimal and unimportant given the numerous other choices we have to affect the final images. However, developing the abilities a black and white photographer has to recognize and compose based on tonal light values and variations will only improve our recognition skills in working with color. I carry a body with black and white slide film and a red filter to help me "see" in black and white. I've been told that photographers shouldn't switch back and forth from color to black and white. There's another rule worth breaking! The organ-pipe cactus (above) was photographed with a 24mm lens and polarizer against a blue sky at sunset, underexposed one-half stop. Here, the sunset and tonal contrast of the cactus against the darkening sky invited further investigation.

There's another rule worth breaking!

These gardens and fruit trees were photographed in the early morning with a 70–210mm lens and polarizing filter. This image was one-half stop underexposed. The morning light, pattern, reflection, and tonal difference inherent in the scene created this opportunity.

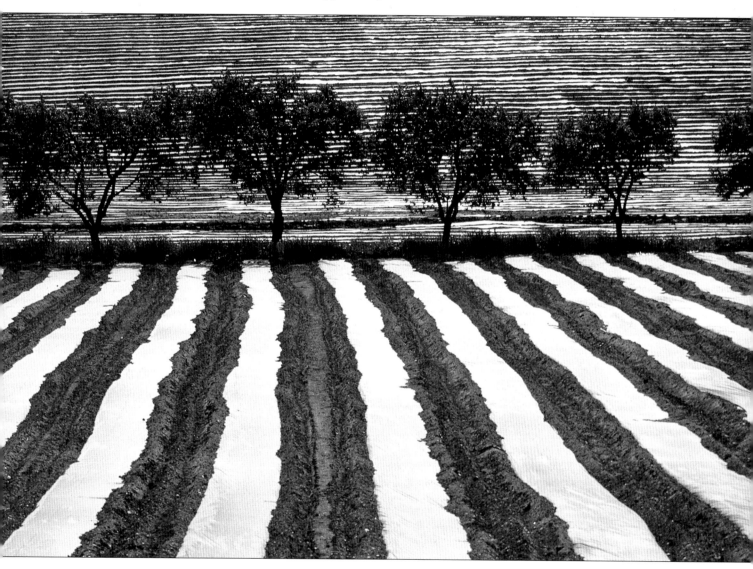

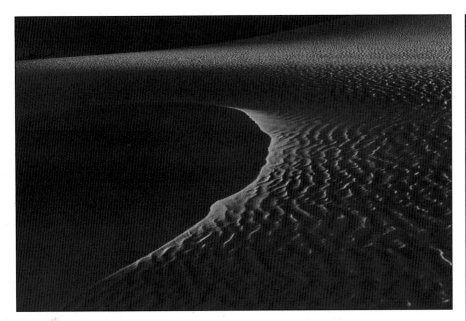

Light is capable of touching the landscape in wonderfully subtle ways, delicately etching textures, and rendering painterly hues. A photographer's ability to perceive these nuances is directly proportionate to the amount of time spent seeing.

Above, the last few seconds of available light washes over a ridge with sand striations at White Sands, New Mexico. The effect produced by the day's last light, the texture, and the shadows that formed attracted me to this landscape.

On the opposite page, the effect of soft twilight is evident in an image of cornflowers and eryngium made with a 70–210mm zoom at F4.

Light is capable

of touching the landscape

in wonderfully subtle ways...

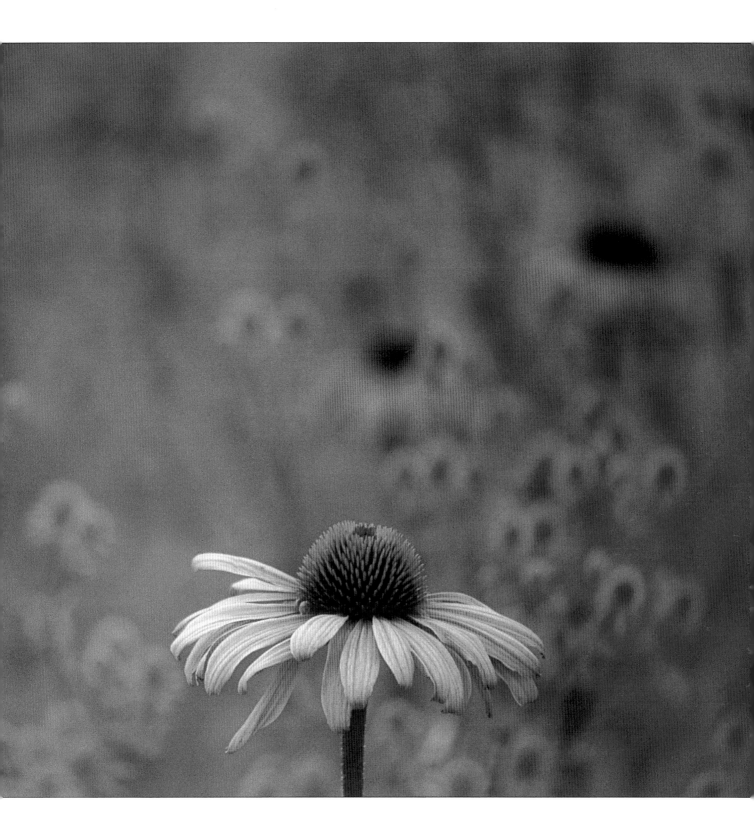

4.

Drawing from the Well

HAVE YOU EVER WONDERED WHAT IT IS that propels some individuals to continuously explore, to go beyond the boundaries that most of us accept, and continue long after many would have lost interest and faltered? When I began to photograph, the first years were a test of patience as I fumbled through clumsy efforts to unlock the mysteries of light, lens, and film. Even as I struggled with the basic mechanics, I remember feeling somewhere inside me that once this door was opened, it would lead anywhere that my imagination could travel. Years later, those realizations have come true and still continue to grow and thrive. What is even more exciting to me is the fact that this inner feeling of fulfillment and sense of artistic confidence are achievable by each and every photographer through the use of imagination coupled with the camera!

If I had to label what it is that has kept this fire of exploration and invention burning within me for many years, I could use the words excitement, enthusiasm, joy, or euphoria—take your pick. Ultimately and cumulatively, these words can be summarized in one word—*passion*— and passion is a powerful force indeed. Passion will lift you from a warm bed in the middle of the night, and carry you over immense sand dunes to witness the dawn of day. Passion will give strength to your legs as you struggle in three-foot snowdrifts, climbing to a mystical overlook of the wintery landscape below. Passion gives you a new superhuman ability to cross rivers, where you'll balance on

Passion will give strength to your legs as you struggle in three-foot snowdrifts.

fallen logs and step from stone to stone. Passion allows you to ignore your cold, wet clothes and ruined equipment after falling into that same river. Few would disagree that a sense of excitement or passion is what pushes a photographer on, but the question is, how can we ignite and reignite that feeling when it begins to fade? The creative climb, in fact, is often a plateau to plateau journey as we compose ourselves for the next reach. Over the years, I have discovered several ways to lift myself to the next level. Let's examine some of the ways we can keep the well of passion full.

OTHER PHOTOGRAPHERS

Imagine yourself standing in their shoes, behind the camera.

We all are enthused by the works of other photographers, but the next time you view another photographer's work, try viewing it a little differently. Imagine yourself standing in their shoes, behind the camera, making each and every decision. Consider the decisions they have made, then go one step further and visualize the photographic choices we have discussed, making your own creative choices. Perhaps there is a composition within the composition? Would you have used a colored flash, camera motion, or sandwiched slides? With what intent? Might you have used an effective filter? Go through a mental checklist, or even a written one, of the choices you have with your equipment, and really try to visualize the resultant image. One or two magazines or photography books can take hours to imagine your way through. This is an exercise in making your own decisions; the photographs you view are only the starting point! Once you fully realize, "Yes, I *can* imagine and visualize," your own innovative images are sure to follow.

TRAVEL PLAN

Before traveling to a photographic location, research and contemplate your destination thoroughly. Using books, maps, magazines, or pamphlets, think about what you might find there. Your visions need not be 100% factual. In reality, the true goal is that you are actually imagining and considering your photographic responses to your own imagination and vision. You know, for example, that in Death Valley there are immense sand dunes. Close your eyes and imagine standing on them at dawn. Search your

photographic options with the help of questions like these: Will I use my wide angle and the sky to communicate the feeling of space? Will I isolate dark, foreboding shadows and underexpose with my telephoto? Can I catch the wind-driven sand? Shall I select a pattern of shadows and sand ripples? Utilize some faint footprints? Perhaps you'll travel to a meadow of wildflowers, or an alkali lake surrounded by waving fox grass, or misted maple woods in autumn. As you consider each and every one of your photographic options in each of these researched and imagined places, the resultant ideas will be implanted in your mind. When you do encounter reality, you will be bursting with creative choices—and the accompanying excitement!

OTHER ARTISTS

Spend time in art galleries and take time to reach a little deeper into your understanding and appreciation of painters and sculptors. Listen to the artists and the reasons and feelings behind their selection and placement of particular colors and hues, shadow and light, shape and line in chosen ways. Your own personal responses will begin to clarify, and become more evident in your own images as you learn to really see shape, color, and light quite differently from many other photographers. Listen carefully, and your eyes and heart will become sensitive to the artists' world of light and design. Allow yourself to be inspired by them, and, in time, you also will inspire others. This has been a wonderful influence and a well of passion for me, right from the beginning.

Reach a little deeper into your understanding and appreciation of painters and sculptors.

MUSIC

Listen to music at home and as you travel. I find that having quiet time and a darkened room to sit in, listening to expressive or mood music is especially regenerative. Full orchestral pieces, movie soundtracks, and New Age with sweeping synthesizers can carry our minds to imagined places. It is during such moments that I often visualize the sequence and theme of slide presentations. As I allow the music to carry me, the images I visualize and the flow of notes become one entity. Each blends with the other to become a feeling even greater than their sum. Their synergy can be a tremendous lift. Kitaro, Ray Lynch, Vangelis and Patrick O'Hearn are some of my favorites, but any

music that touches your heart and draws an emotional response from you can lead you to the true goal.

OURSELVES

Take a trip when you need it! This isn't quite what it sounds like. The trip I am referring to involves our minds once again. Keep your favorite images in a file, and on some dark, winter night, place them in a slide viewer and enjoy. Recall, remember, and rekindle the magic you felt in those photographic moments, giving yourself the strokes you deserve. As you revisit these moments, write down or make a mental note of the sensations that you had. Ask yourself, was the light changing? Was it windy? Were there clouds moving overhead? Did I recognize these opportunities and consider all my photographic choices? The process of recalling will give you confidence that future situations are truly opportunities. Confidence tells us that we have done it, and that we can do it again.

KNOW YOUR CAMERA

Think of your camera as a musician would of his chosen instrument. Can you, for example, change and make aperture and shutter speed adjustments in the dark? This skill takes some practice, but when achieved, it will free your mind for more important considerations. If I were unable to experience freedom with my camera, I would probably move to a simpler one. I would want my own responses to be free and fluid, rather than having continually to cope with the technological complexities of the camera. Intimate relationships with ones' tools or instruments instills confidence, and makes them an important ally when we are presented with a creative opportunity.

ASSIGNMENT BOARD

You might want to make an assignment board for yourself. This can be as simple as keeping a list of places, subjects, times and thoughts that you can draw from and use as a reminder at certain times of the year. Keep local maps marked with notes on waterfalls, flower fields, blankets of ferns, tree stands and anything else that you might return to at a different time or season. Often, when we think about the images made from a first visit, we can conceive photographic approaches that we didn't use, and we can

Ask yourself, was the light changing? Was it windy?

make the decision to use them the next time around. An assignment board keeps the I-don't-know-what-to-photograph syndrome at bay. When we encounter an appealing idea or subject, the lighting or some other variable isn't always exactly right; sometimes it's better to wait for the right opportunity than to act. Write the idea down and its time will come. While luck does play some part in the frequency of the photographic opportunities we encounter, a much more efficient strategy is what I call the "Five W" plan. We do have the ability to decide what it is that we wish to photograph, where our subject is, when we should be there, why were we attracted to this landscape, and which of our responses we might utilize. What, where, when, why, and which—these are the five questions that must be answered in our creative quest.

READ THE WEATHER

Learn to read the skies and weather. I have risen many times in the early dawn, and by observing the cloud cover or sky, have been able to decide on the location best suited to the anticipated light. Knowing where and when mists will form, that ominous clouds are building, or a soft rain is on its way helps us to select our location and be there for those special moments. My assignment board and intuitions of weather work closely together. In many instances I know the what, where, when, why and which of photographs I haven't taken. Being in control, rather than searching aimlessly, is exciting. Accept the weather and be a part of it! Changing, seemingly inclement weather is part of nature and life, and hiding in wait for warm, sunny days is a sure way to deprive ourselves of wonderful photographic opportunities. Acquire a raincoat, umbrella, rubber boots, a snowsuit, hat and gloves, and learn firsthand that what we perceive as bad weather is often responsible for great photographs. It will only be a matter of time before you actually encounter the one image you thought you would never see. Trust me.

Being in control, rather than searching aimlessly, is exciting.

PHOTOGRAPH FOR YOURSELF

This may sound easy, but ask yourself: Am I attempting to please or impress my family and friends? Fellow club members and judges? A calendar company? A client? Magazine editors? All of the above? If your name isn't on

Creativity
is a personal
and individual
journey.

this list, it is time to add it—and you must place it at the top. Creativity is a personal and individual journey that is often appreciated and savored by the creator alone. Don't expect everyone to understand your photographs, or to enter into a moment that only you have experienced. Be creative and express yourself for your own sake; there is no greater validation for your photographs!

To summarize, some pathways to motivation and persistence are:

- Other photographers
- Travel plan
- Other artists
- Music
- Ourselves
- Know your camera
- Assignment board
- Read the weather
- Photograph for yourself

Keeping our passion alive for creative photography is as important as our observational skills and the recognition of our responses to the landscape we explore. Without it, our creative conversation eventually dwindles to a whisper.

Gallery
Five

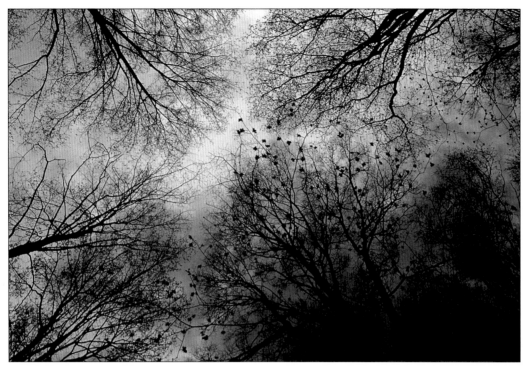

Images with effective moods are the essential ingredients of slide shows. Create strong moods or themes for a sequence or grouping, and your viewers will become more involved in the experience. By working with photographs of varying moods, the audience is taken on an emotional ride and is compelled by the arresting power of emotion. These two images illustrate opposites: a mysterious foreboding woods (above) is contrasted with the joyous awakening of spring (below); black, reaching limbs against a gray sky contrasts with a rainwashed yellow iris with a diffused and softened background. Be aware of how you feel about the landscape, and always guide your creative choices in the same direction.

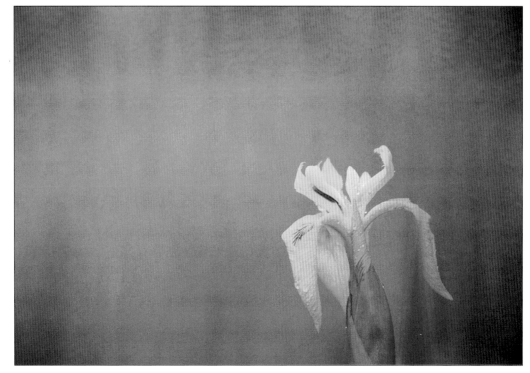

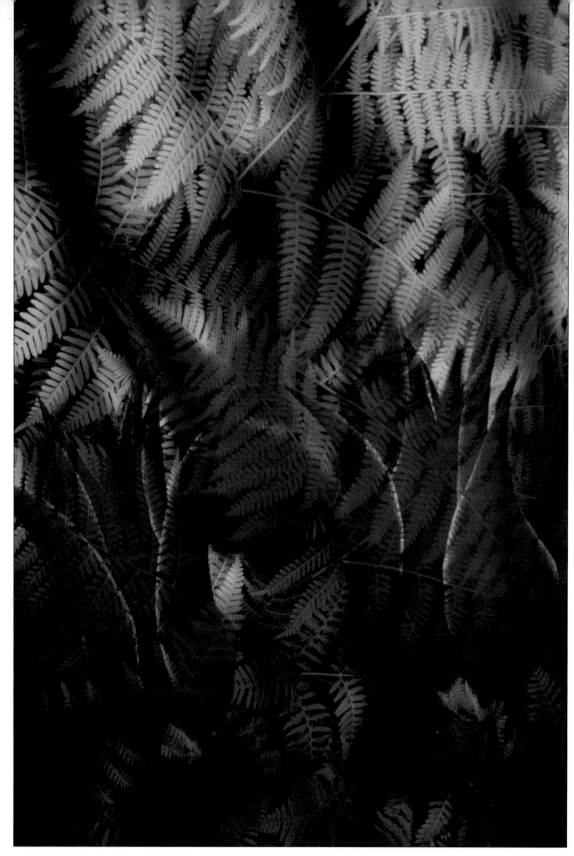

When we begin to compile a library of visual components—overexposed patterns, textures and wash-es, etc.—and regularly review this file, interesting marriages will occur. The tulips and ferns above combine to produce an intricate weave of color and pattern. The ferns are an overexposed black and white transparency. Opposite, Scotch broom flowers, sandwiched with an out-of-focus image of the complete plant, create a renaissance feel. Gathering the components is just the beginning.

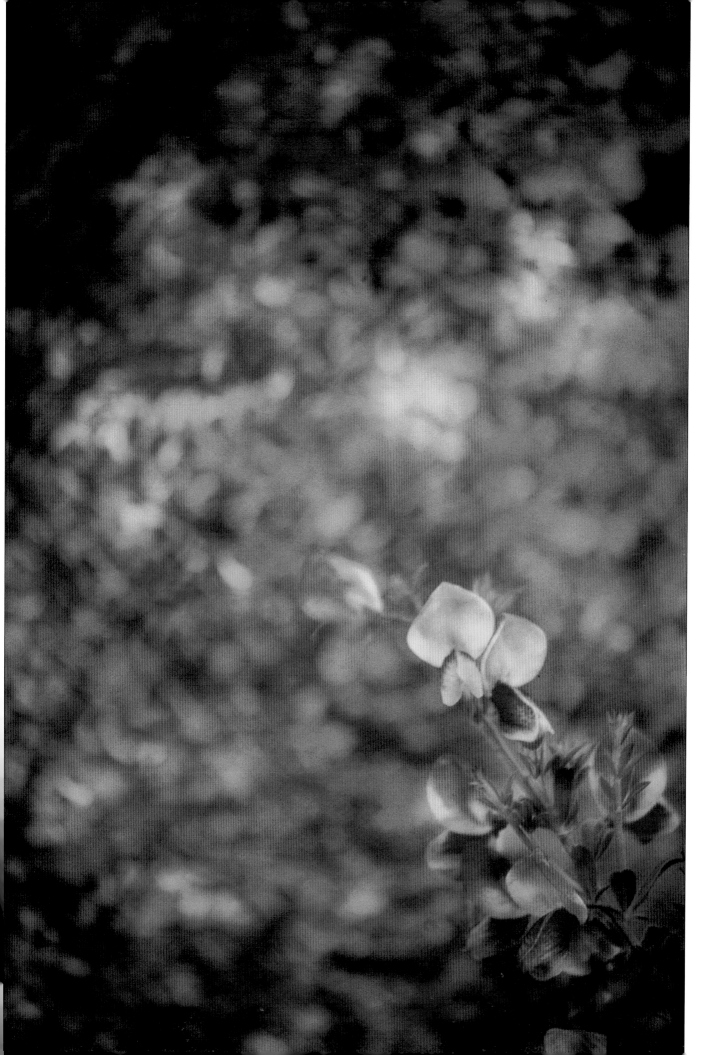

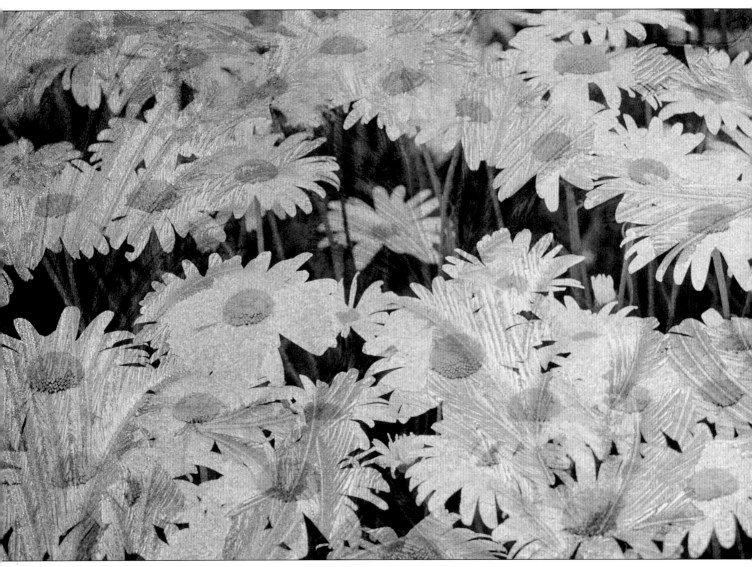

Images created for use as patterned, textured, and overexposed components can be used in a number of ways. In this pair of images, I've used one such component image—a frost pattern—in two ways. In the image above, the frost image is combined with an arrangement of daisies. When the two images are combined, the frosty textural element lends an etched quality to the recognizable shapes of the flowers.

The frosty textural element lends an etched quality.

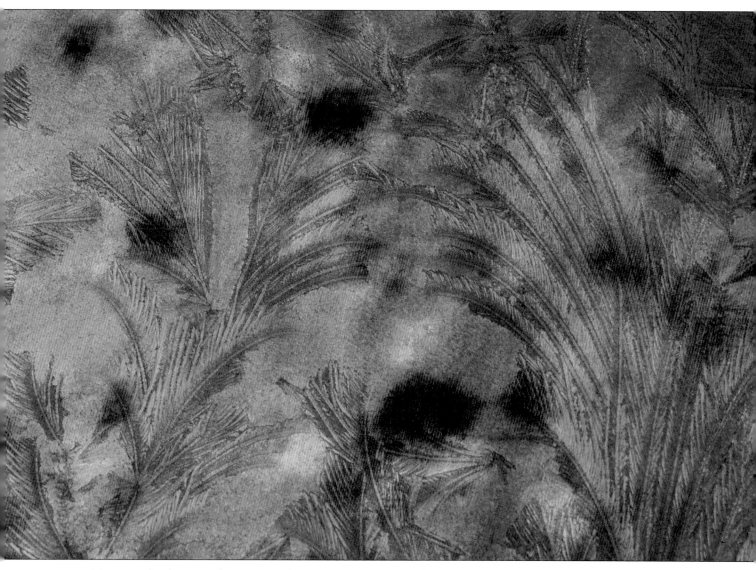

In this example, the same frost pattern becomes the dominant feature of the image when combined with an out-of-focus wash of wild flowers.

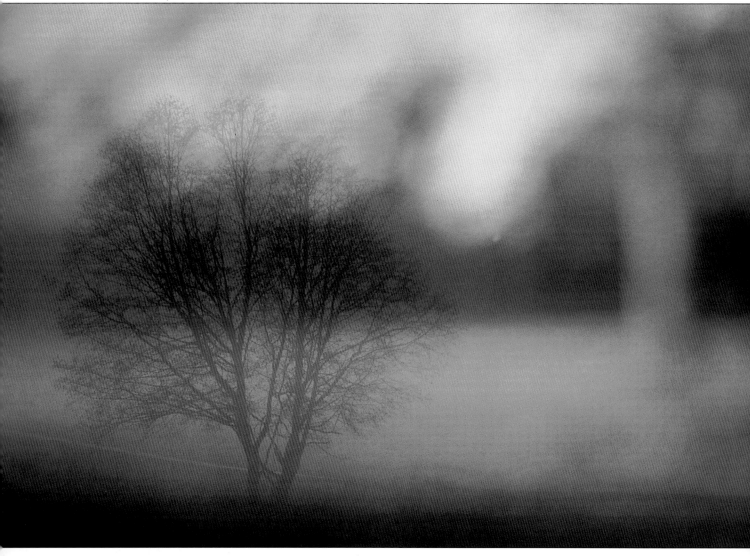

You may have noticed that many of my images are based on the raw visual materials derived from trees. As elements of most landscapes, they would be nearly impossible to omit, but seeing beyond the trees can open a forest of possibilities. The image above is a sandwich created with two distinctly different components. The base image is a silhouette of an alder in the mist, which appealed to me because of the soft light and stark contrast, while the color component is an out-of-focus maple tree and foreground. I was drawn to the image of the maple by the monochromatic color and the striking effects of the morning light from behind me. Together, they eloquently portrayed the passage of the seasons.

Seeing beyond the trees can open a forest of possibilities.

My fascination

with trees continues.

Exploring the canopy of this autumn soft maple, I made a decision to further emphasize the pattern of the radiating dark branches, and block out the distracting highlights that were visible through the open spaces between the leaves. To accomplish this, I sandwiched slides of two different compositions of the same tree—one in focus, the other in soft focus. The slides were overexposed one and two stops respectively. My fascination with trees continues.

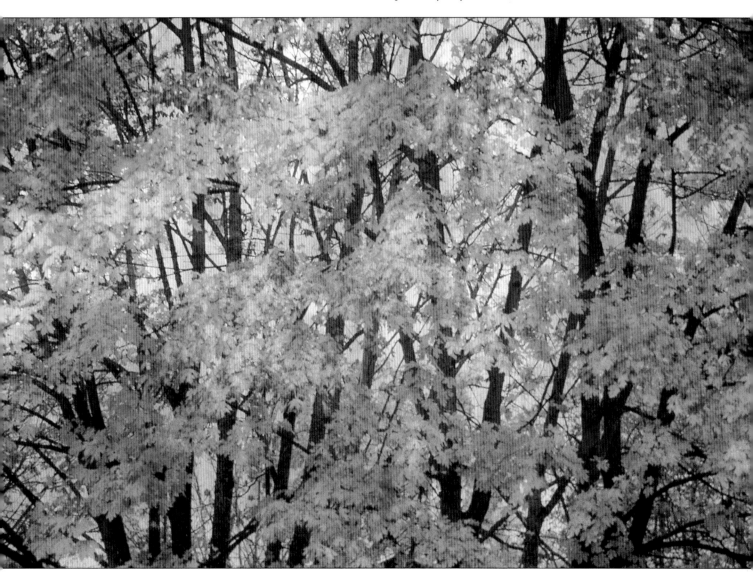

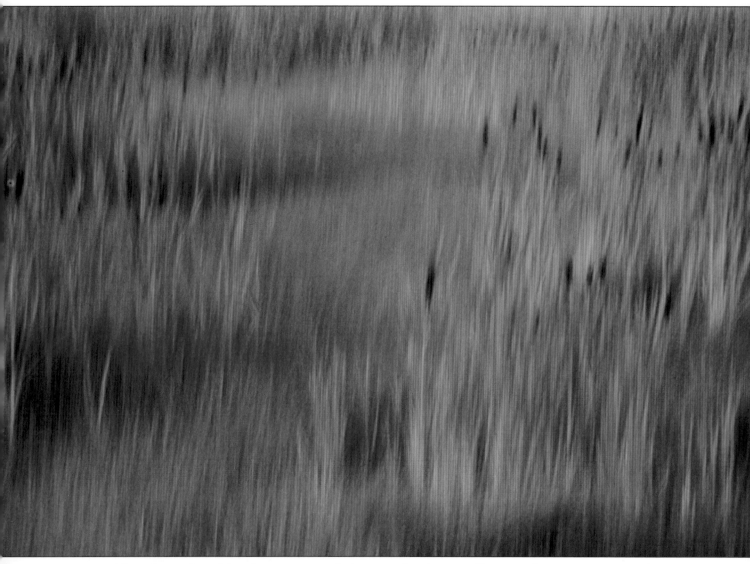

Observing and studying the nuances, techniques, and various mediums within the spectrum of the visual arts will affect the ways we respond to our raw visual matter. The elongated stems, leaves and seedpods of these cattails (above) immediately brought to mind the multiple strokes of a pastel pencil drawing I had viewed. I used camera motion and an exposure of $^1/_8$ of a second to impart a sketched feel to the resultant image.

Perhaps I'll turn to painting someday, with total freedom to shape and select all aspects of imagery. Until then, I must rely on the landscapes I visit, which fortunately never cease to amaze me. In watercolor-like fashion, the mosses in this landscape (opposite) have transformed the shoreline stones and grasses. The appropriate slide sandwich emphasized the bright colors and the tonal contrast with the submerged stones and a line of gray stones. Would I see this way if I had not been exposed to other art forms? I doubt it.

The appropriate slide sandwich emphasized the bright colors...

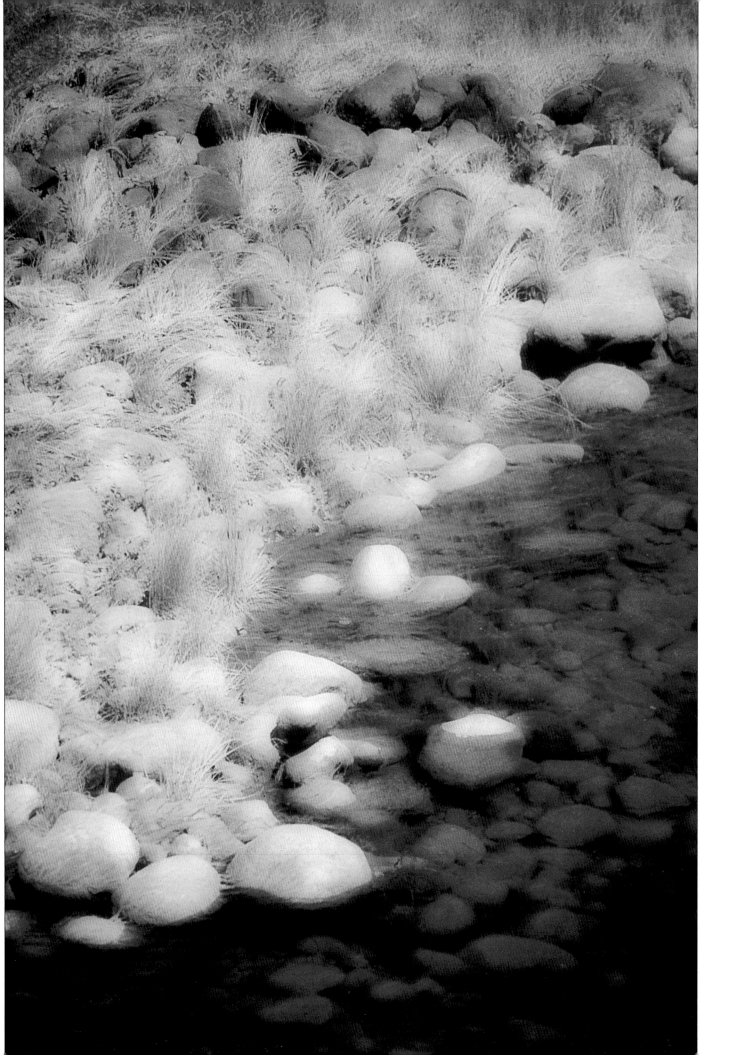

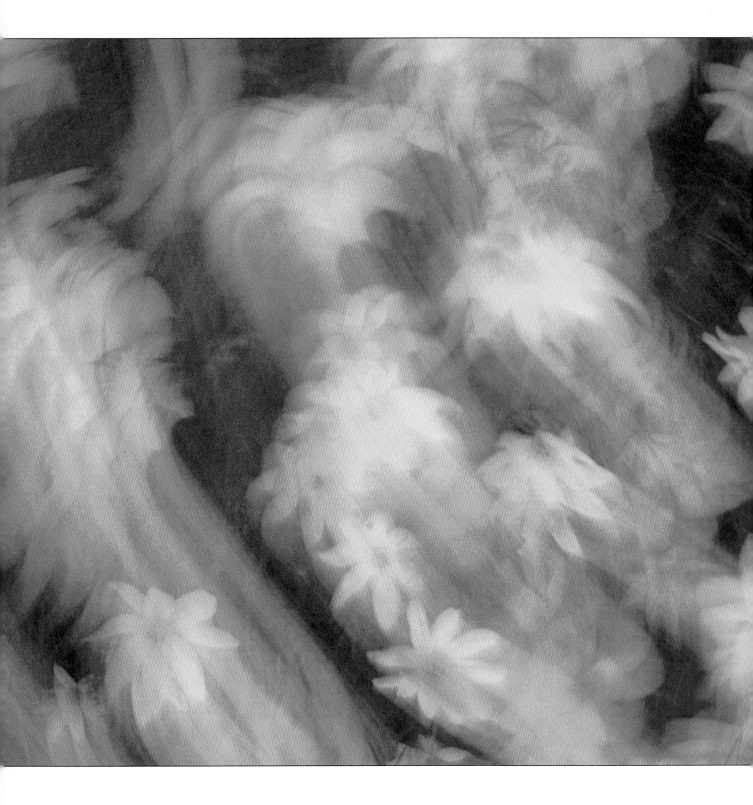

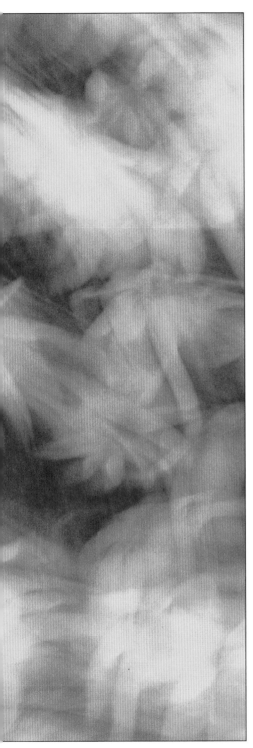

Often, the ability to paint with our cameras relies as much on the space between our subjects as the subject itself. In the image above, I selected a tiny circular motion, tracing, as you can see, the center of the colorful cosmos. This retained the shape, yet gave a painterly feel to each flower, while blending, and, in effect, erasing their stems to create an impression of flowers floating on the background.

While there was no wind moving these yellow tickseed flowers (opposite), I mimicked the swaying action the wind might cause by stroking and twisting my camera at the same time. I practiced these techniques, and observed where each motion blur would be painted, maximizing the use of the contrasting space between the flowers.

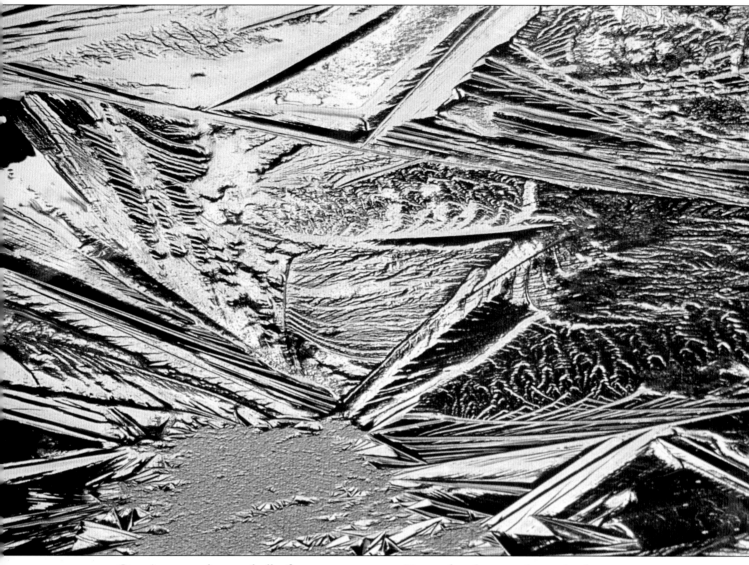

Opening ourselves and all of our senses up to the details that surround us may seem like a daunting mode of observation to be in. Don't despair—it becomes easier with practice. In the images shown above and on the facing page, I have swung from one focal length to the extreme opposite. Above, while balanced on a floating log, photographing dead cedar skeletons standing in a lake, I glanced down to assure myself that I had safe footing. These newly forming ice crystals were literally beneath my feet.

Don't despair—it becomes easier with practice.

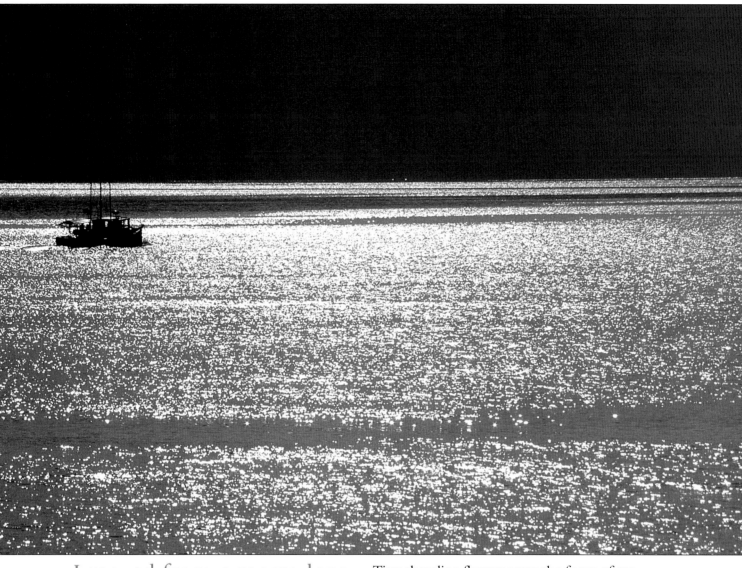

I moved from a macro lens

to a 300mm lens

in seconds.

Tiny shoreline flowers were the focus of my attention when I heard the distant foghorn and turned to the source. I moved from a macro lens to a 300mm lens in seconds. By predicting the boat's movement, I was able to select an area of reflection to etch a silhouette against. The distant fog bank soon consumed the tiny craft, and my attention returned to the shoreline vegetation.

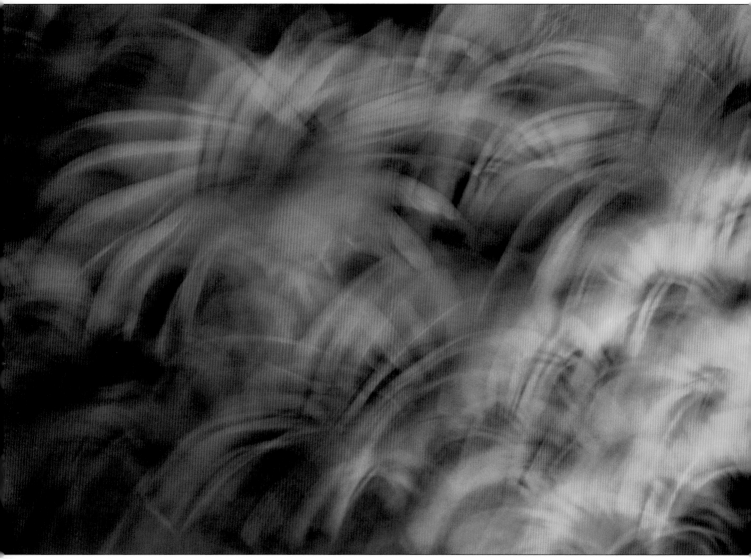

Photographing flowers—how can we resist? Their colors stretch from one end of the palette to the other. Their various shapes and curves are awe-inspiring. We are lifted by their presence and drawn to them with cameras in hand when we find them in the wild. Study the structure and shape of the flowers, and the patterns they form, and visualize and rehearse the appropriate camera motion—or painting stroke, as I prefer—and you will enter an impressionistic world of flowing, blended florals. To create this image of the cornflowers, I utilized an abbreviated arc motion with the camera.

Photographing flowers—
how can we resist?

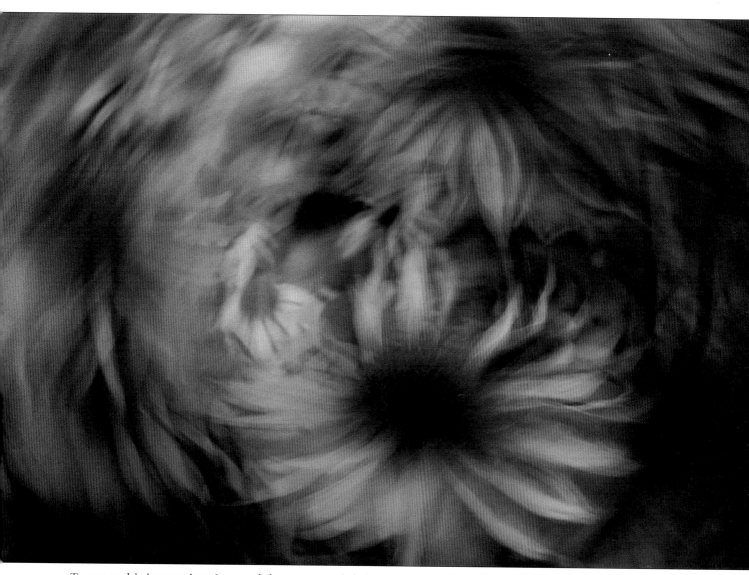

To create this impression, I rotated the camera, while keeping the defined flower at the center of the rotation. How do I spell flowers? F-r-e-e-d-o-m.

Ultimately, we create for ourselves, making decisions according to our own unique responses in each situation. There are several other approaches that I could have explored in these two images. Think through our list of choices and visualize them.

The image above shows a bed of tulips photographed through a flowering cherry tree with a 70–210mm zoom at F4. The tulips appear as an out-of-focus colored pattern.

In the image on the facing page, I played with the rigid repetition of the fence slats and the contrasting soft cascade of curved branches and rounded fruit. I softened the resultant image considerably by sandwiching the two slides, both overexposed two stops. This technique has been dubbed "Orton Imagery."

Landscape photographers tend to exclude evidence of human manipulation to the environment in presenting idealistic visions of nature and wilderness. Could these idealistic images represent our silent wish, the way we would like our earth to be? I'm sure we've all considered this possibility. Man's presence and impact on the landscape is undeniable, however, and as creative photographers, why should we not be open to this?

In this black and white image (above) of a white church against the blue sky (I darkened the blue sky with a polarizer), I have taken advantage of the tonal contrast and colored the lighter areas with a sandwich of fall maples from the surrounding hillsides of New England.

To create the image on the opposite page, I sandwiched a high-contrast black and white image of a windmill and fence with one of a field full of the flowers generally associated with windmills—tulips. Each combination becomes a more effective expression of time and place, a created, and creative vision.

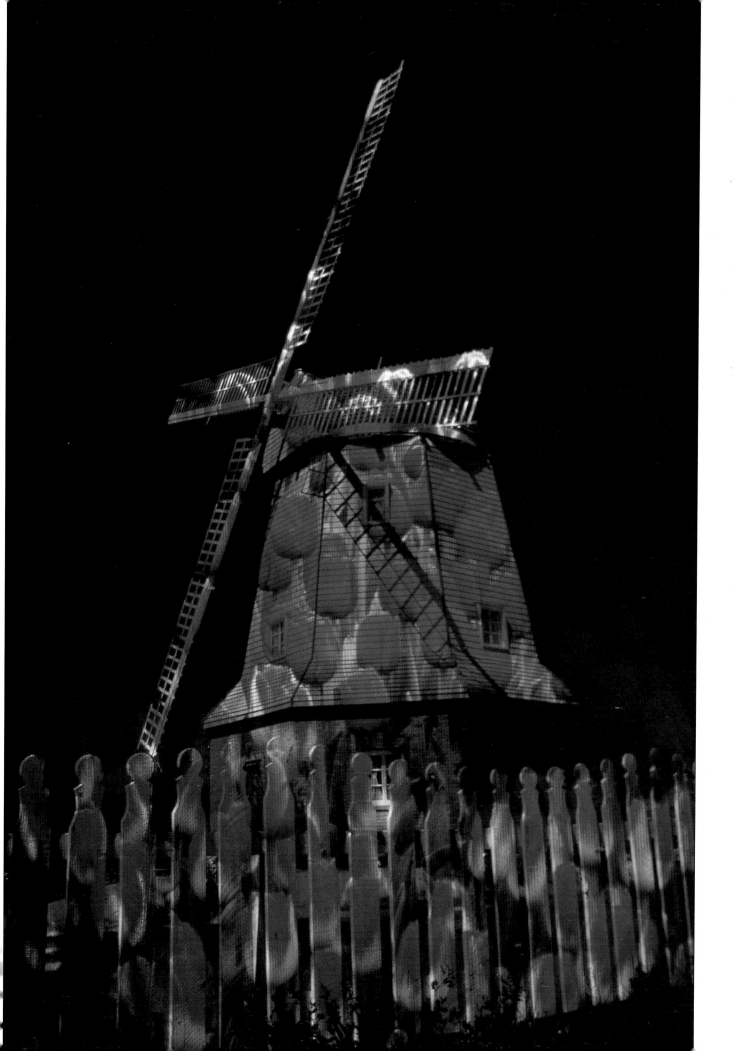

Conclusion

SEVERAL YEARS AGO, I was asked to teach a workshop on creative photography. It was my first workshop as an instructor. As a matter of fact, I had never even attended a workshop as a participant, so I was rather uneasy as the date approached. I researched and compiled stacks of material to present. When the day finally arrived, I walked the hallway to the classroom with trepidation. I introduced myself, and had my students do the same. We briefly talked about the camera so that I could gauge their level of technical knowledge, and then asked a question—the importance of which was not apparent until some time later—why are you here?

Though worded differently, each respondent had a common factor in their reply, and when everyone had finished, we knew our goal. We filed the written material I had prepared and headed outdoors with our cameras. We got to know each other very quickly, and I noted how each individual's personality shaped the way that they saw and approached situations.

Moving from one to another, I drew attention to the various possibilities in each location, followed by, "what if?" I then encouraged each individual to visualize and shape their own decisions. We tackled technical questions on equipment as they arose, stressing exploration, imagination and visualization instead. I am sure that some of my suggestions earned me some puzzled looks, for example:

I am sure that some of my suggestions earned me some puzzled looks.

Crawl inside a seed pod. Be carried by the wind. Stroke the water's surface.

The week passed very quickly, and on the final day we gathered to have a final slide show of images. There were looks of amazement as many didn't recognize their own images, while others admired and asked, "How did this happen?" It was quite overwhelming to witness this transition—a graduation, for some, to another level of seeing, which opened a new world for their exploration. From here, each would choose their own destination. Nothing more needed to be said after seeing those images. Each one now held a truly personal impression of the landscape, and knew that the ability to create truly unique imagery was within their grasp. We shook hands, hugged, exchanged wishes for the future, and it was over. I realized then, as I do now, that I couldn't teach creativity, but I could serve as a catalyst in this creative cycle.

The choices I've presented you with are only the beginning.

There are three entities within the cycle of photographic creativity, our creative conversation. First is the ability to see, to develop our vision, to sense opportunities, and to question them. Second is being able to respond with our photographic choices, and third, to draw from within ourselves and others, the emotional sustenance, the passion, to fuel this conversation onward. In one way, we can consider creativity akin to pure problem resolution, exposing and considering all possible solutions to each situation that we are given. In the center of this conversation, however, is the photographer, you, the director and decision maker, always effecting each bit of visual information, each choice, each interpretation.

We mentioned earlier that making a commitment to find space in our photographic endeavors to push our creative boundaries is the most difficult decision to make. You may now feel that you have had the tools, the ingredients to be creative all along, and didn't realize it. You're probably right! Creativity, like so many of our other daily choices, involves making and evaluating decisions. The choices I've presented you with are only the beginning. If you have made the commitment to be creative, you are, in fact, already on the journey.

IMAGINATION

+ Composition
+ Depth of field
+ Exposure
+ Lens choice
+ Multiple exposures
+ Sandwiched images
+ Zoomed exposures
+ Flash
+ Shutter speeds
+ Camera motion
+ Filters
+ Diffusion
+ Angle of view
+ Film
+ Combinations

VISION

+ Color
+ Quality of light
+ Direction of light
+ Patterns and textures
+ Reflections
+ Motion
+ Weather effects
+ Translucence
+ Sunrise/sunset
+ Shadows/tonal contrast

The Cycle of Photographic Creativity

Photographic Choices/Options — Initial Attraction/Visual Quality — Motivation — Persistance

PASSION

+ Other photographers
+ Travel plan
+ Other artists
+ Music
+ Ourselves
+ Know your camera
+ Assignment board
+ Read the weather
+ Photograph for yourself

About the Author

Michael Orton photographs and travels throughout North America from his base on Vancouver Island. His distinctive style of creative landscape photography is often described as impressionistic and watercolor-like.

He has twice been a feature speaker at Camera Canada College, Canada's national seminar at the University of British Columbia. In addition, he has taught creative photography at the Okanogan Summer School of the arts and at various workshops.

Michael's images have been featured in *Popular Photography, Petersen's Photographic,* and *Photo Life,* as well as Britain's *Amateur Photographer* and *Photo Technique.* His images are sold worldwide for corporate advertising, television and video, magazines, books and fine art prints.

For more information on Michael Orton or his work, you can visit his website at <www.michaelorton.com>.

Index

Other Books from
Amherst Media, Inc.

Infrared Landscape Photography

Todd Damiano

Landscapes shot with infrared can become breathtaking and ghostly images. The author analyzes over fifty of his most compelling photographs to teach you the techniques you need to capture landscapes with infrared. $29.95 list, 8½x11, 120p, 60 b&w photos, index, order no. 1636.

Infrared Photography Handbook

Laurie White

Covers black and white infrared photography: focus, lenses, film loading, film speed rating, batch testing, paper stocks, and filters. Black & white photos illustrate how IR film reacts. $29.95 list, 8½x11, 104p, 50 b&w photos, charts & diagrams, order no. 1419.

Computer Photography Handbook

Rob Sheppard

Make the most of your photographs using computer technology! From creating images with digital cameras, to scanning prints and negatives, to manipulating images, you'll learn all the basics of digital imaging. $29.95 list, 8½x11, 128p, 150+ photos, index, order no. 1560.

Achieving the Ultimate Image

Ernst Wildi

Ernst Wildi teaches the techniques required to take world class, technically flawless photos. Features: exposure, metering, the Zone System, composition, evaluating an image, and more! $29.95 list, 8½x11, 128p, 120 b&w and color photos, index, order no. 1628.

Build Your Own Home Darkroom

Lista Duren & Will McDonald

This classic book teaches you how to build a high quality, inexpensive darkroom in your basement, spare room, or almost anywhere. Includes valuable information on: darkroom design, woodworking, tools, and more! $17.95 list, 8½x11, 160p, 50 photos, many illustrations, order no. 1092.

Into Your Darkroom Step-by-Step

Dennis P. Curtin

This is the ideal beginning darkroom guide. Easy to follow and fully illustrated each step of the way. Includes information on: the equipment you'll need, set-up, making proof sheets and much more! $17.95 list, 8½x11, 90p, hundreds of photos, order no. 1093.

Special Effects Photography Handbook

Elinor Stecker-Orel

Create magic on film with special effects! Little or no additional equipment required, use things you probably have around the house. Step-by-step instructions guide you through each effect. $29.95 list, 8½x11, 112p, 80+ color and b&w photos, index, glossary, order no. 1614.

Big Bucks Selling Your Photography, *2nd Edition*

Cliff Hollenbeck

A completly updated photo business package. Includes starting.up, getting pricing, creating successful portfolios and using the internet as a tool! Features setting financial, marketing and creative goals. Organize your business planning, bookkeeping, and taxes. $17.95 list, 8½, 128p, 30 photos, b&w, order no. 1177.

Telephoto Lens Photography

Rob Sheppard

A complete guide for telephoto lenses. Shows you how to take great wildlife photos, portraits, sports and action shots, travel pics, and much more! Features over 100 photographic examples. $17.95 list, 8½x11, 112p, b&w and color photos, index, glossary, appendices, order no. 1606.

Outdoor and Location Portrait Photography

Jeff Smith

Learn how to work with natural light, select locations, and make clients look their best. Step-by-step discussions and helpful illustrations teach you the techniques you need to shoot outdoor portraits like a pro! $29.95 list, 8½x11, 128p, 60+ b&w and color photos, index, order no. 1632.

Essential Skills for Nature Photography

Cub Kahn

Learn all the skills you need to capture landscapes, animals, flowers and the entire natural world on film. Includes: selecting equipment, choosing locations, evaluating compositions, filters, and much more! $29.95 list, 8½x11, 128p, 60 photos, order no. 1652.

The Art of Infrared Photography, *4th Edition*

Joe Paduano

A practical guide to the art of infrared photography. Tells what to expect and how to control results. Includes: anticipating effects, color infrared, digital infrared, using filters, focusing, developing, printing, handcoloring, toning, and more! $29.95 list, 8½x11, 112p, 70 photos, order no. 1052

How to Buy and Sell Used Cameras

David Neil Arndt

Learn the skills you need to evaluate the cosmetic and mechanical condition of used cameras, and buy or sell them for the best price possible. Also learn the best places to buy/sell and how to find the equipment you want. $19.95 list, 8½x11, 112p, b&w, 60 photos, order no. 1703.

Basic Digital Photography

Ron Eggers

Step-by-step text and clear explanations teach you how to select and use all types of digital cameras. Learn all the basics with no-nonsense, easy to follow text designed to bring even true novices up to speed quickly and easily. $17.95 list, 8½x11, 80p, 40 b&w photos, order no. 1701.

Black & White Landscape Photography

John Collett and David Collett

Master the art of b&w landscape photography. Includes: selecting equipment (cameras, lenses, filters, etc.) for landscape photography, shooting in the field, using the Zone System, and printing your images for professional results. $29.95 list, 8½x11, 128p, 80 b&w photos, order no. 1654.

Black & White Photography for 35mm

Richard Mizdal

A guide to shooting and darkroom techniques! Perfect for beginning or intermediate photographers who want to improve their skills. Features helpful illustrations and exercises to make every concept clear and easy to follow. $29.95 list, 8½x11, 128p, 100+ b&w photos, order no. 1670.

Medium Format Cameras: User's Guide to Buying and Shooting

Peter Williams

An in-depth introduction to medium format cameras and the photographic possiblities they offer. This book is geared toward intermediate to professional photographers who feel limited by the 35mm format. $19.95 list, 8½x11, 112p, 50 photos, order no. 1711.

Photo Retouching with Adobe® Photoshop®

Gwen Lute

Designed for photographers, this manual teaches every phase of the process, from scanning to final output. Learn to restore damaged photos, correct imperfections, create realistic composite images and correct for dazzling color. $29.95 list, 8½x11, 120p, 60+ photos, order no. 1660.

Secrets of Successful Aerial Photography

Richard Eller

Learn how to plan for every aspect of a shoot and take the best possible images from the air. Discover how to control camera movement, compensate for environmental conditions and compose outstanding aerial images. $29.95 list, 8½x11, 120p, 100 photos, order no. 1679.

Professional Secrets of Nature Photography

Judy Holmes

Improve your nature photography with this must-have book. Covers every aspect of making top-quality images, from selecting the right equipment, to choosing the best subjects, to shooting techniques for professional results every time. $29.95 list, 8½x11, 120p, 100 color photos, order no. 1682.

Macro and Close-up Photography Handbook

Stan Sholik

Learn to get close and capture breathtaking images of small subjects – flowers, stamps, jewelry, insects, etc. Designed with the 35mm shooter in mind, this is a comprehensive manual full of step-by-step techniques. $29.95 list, 8½x11, 120p, 80 photos, order no. 1686.

Composition Techniques from a Master Photographer

Ernst Wildi

In photography, composition can make the difference between dull and dazzling. Master photographer Ernst Wildi teaches you his techniques for evaluating subjects and composing powerful images in this beautiful full color book. $29.95 list, 8½x11, 128p, 100+ full color photos order no. 1685.

Outdoor and Survival Skills for Nature Photographers

Ralph LaPlant and Amy Sharpe

An essential guide for photographing outdoors. Learn all the skills you need to have a safe and productive shoot – from selecting equipment, to finding subjects, to dealing with injuries. $17.95 list, 8½x11, 80p, order no. 1678.

Art and Science of Butterfly Photography

William Folsom

Learn to understand and predict butterfly behavior (including feeding, mating and migrational patterns), when to photograph them and even how to lure butterflies. Then discover the photographic techniques for capturing breath-taking images of these colorful creatures. $29.95 list, 8½x11, 120p, 100 photos, order no. 1680.

Practical Manual of Captive Animal Photography

Michael Havelin

Learn the environmental and preservational advantages of photographing animals in captivity – as well as how to take dazzling, natural-looking photos of captive subjects (in zoos, preserves, aquariums, etc.). $29.95 list, 8½x11, 120p, 100 photos, order no. 1683.

Watercolor Portrait Photography: The Art of Manipulating Polaroid SX-70 Images

Helen T. Boursier

Create one-of-a-kind images with this surprisingly easy artistic technique. $29.95 list, 8½x11, 120p, 200+ color photos, order no. 1698.

Techniques for Black & White Photography: Creativity and Design

Roger Fremier

Harness your creativity and improve your photographic design with these techniques and exercises. From shooting to editing your results, it's a complete course for photographers who want to be more creative. $19.95 list, 8½x11, 112p, 30 photos, order no. 1699.